SYNTHESIS

LOST AND FOUND IN AMERICA

THE ART OF
VESNA KITTELSON

SYNTHESIS

LOST AND FOUND IN AMERICA

THE ART OF
VESNA KITTELSON

FOREWORD BY LYNDEL KING

AFTON PRESS

Editor: Laura J. Westlund
Designed by Molly Ruoho, Smart Set, Inc., smartset.com
Art direction by Kevin Brown, Smart Set, Inc., smartset.com
Jacket designed by Vesna Kittelson and Molly Ruoho
Photographer: Rik Sferra

Printed in the USA.

Publisher: Ian Graham Leask

Afton Press
6800 France Ave. S., Suite 370
Edina, MN 55435
651-436-8443
www.aftonpress.com

Distributed by the University of Minnesota Press
111 Third Avenue South, Suite 290
Minneapolis, MN 55401-2520
http://www.upress.umn.edu

Afton Press gratefully acknowledges individual donations and the generous operating support from TARGET Foundation and Elmer L. & Eleanor J. Andersen Foundation.

Library of Congress Cataloging-in-Publication Data

Names: Kittelson, Vesna, 1947- artist. | King, Lyndel Saunders, writer of
 foreword.
Title: Synthesis : lost and found in America / [Vesna Kittelson].
Description: First edition. | Edina, MN : Afton Press, [2020] | "The art of
 Vesna Kittelson."
Identifiers: LCCN 2020002551 | ISBN 9781890434946 (hardcover)
Subjects: LCSH: Kittelson, Vesna, 1947---Themes, motives.
Classification: LCC ND237.K5528 A4 2020 | DDC 759.13--dc23
LC record available at https://lccn.loc.gov/2020002551

TO MY INSPIRING AND ART-LOVING GRANDCHILDREN,
ISABELLA AND GIOVANNI

CONTENTS

1 *Foreword*
 Lyndel King

3 *One Question Is Not Enough:*
 The Impact of WARM on the Early Color Works of Vesna Krezich Kittelson
 Heather Carroll

27 *War Paintings*
 Wendy Fernstrum

39 *To Catch the Fact:*
 Vesna Kittelson's Self-Portraits
 Camille LeFevre

51 *Young Americans*
 Susannah Schouweiler

71 *Cosmopolitan Imagination:*
 Myth, History, Memory in Vesna Kittelson's Paintings
 Joanna Inglot

83 *(De)Constructing Books*
 John Lyon

107 *Fountains: Of Glitter and Glints*
 Kerry A. Morgan

113 *Alphabet of Ruins*
 Marcia Reed

129 Contributors

131 Acknowledgments

133 Museum Collections

FOREWORD

Lyndel King

Each of the contributors to this book selected a period in the life and work of artist Vesna Kittelson to examine carefully. They linked life experiences and artistic experiences to artworks that Vesna created from the time she was a student at the University of Minnesota in the 1970s to today.

Vesna grew up in Split, Yugoslavia (now Croatia), during the Communist era. The influence of this place and time on her art has been called out in different ways in the essays here. Vesna's feelings of always being an outsider led her to other immigrants in her *Young Americans* series; not all of the portraits in this series represent immigrants, but many do. This same "outsiderness" perhaps fueled her strong interest in language, in particular the English language. Her attraction to language is important in much of her latest work.

Also significant is the Roman past of Split. Diocletian, who ruthlessly persecuted early Christians and was the first Roman emperor to abdicate that position voluntarily, was born in the region that is now Croatia. The remains of his retirement palace are located in the active urban core of Split and are still very present in the daily life of the city.

The characteristic of Vesna's art that most stands out to me in all her work is *passion*—evident in portraits, gushing urban fountains and running water, war paintings, political statements, abstract compositions, or her later, more conceptual pieces. Vesna is a passionate person, and this quality spills over into every aspect of her life and art.

She does not make minutely organized, superrationalized artworks. Her portraits engage you with their humanness. The fountains and abstractions draw you into a colorful, sometimes chaotic world. Aggressive but not entirely threatening describes her slashed and stacked dictionaries and unbalanced columns and towers. Emotion is the first response to Vesna's artwork. This does not mean it is devoid of intellectual content—far from it. But passion is what brings viewers closer to Vesna's art.

I met Vesna when she was a graduate student. As the new director for what was then called the University Gallery, I was asked to judge an art competition at the University of Minnesota, and I selected Vesna's work as the winner. Years later I encountered her as a full-blown member of our thriving arts community and remembered that incident. I was pleased that I had recognized her talent at such an early stage in both our careers!

The Weisman Art Museum at the University of Minnesota has long been committed to preserving the work of women artists, and we are pleased that Vesna has decided to make WAM the repository of a comprehensive collection of her art. This ensures that the history of her career as a pioneering woman in the arts is remembered, and her legacy as an artist will remain accessible to scholars and to the public. We thank her for her generosity.

Vesna's art has changed quite a lot over the years, as evidenced by this book's essays, which review each part of her oeuvre. But passion binds it all together: that has not changed. Passion links her—and you—to her art.

Renaissance artists WAM

Young Americans

Adriatic Sea, Joan Mitchell, Odyssey

Greek sculpture

Words, peace, Miss ... Stonehenge

Victoria and Albert Museum

Stonehenge, ... oil painting

Ideas

Picasso ... Tolstoy

Acrylic

Renaissance portraits
Book Arts, Louise Bourgeois

Artists' Books, Ancient marbles

Roman sculpture

VAM

Psychology of Art, Europe, Money

America, Sculpture, philosophy, WARM

Democracy, ideology

Murray, Music, Math, language

ONE QUESTION IS NOT ENOUGH

The Impact of WARM on the Early Color Works of Vesna Krezich Kittelson

Heather Carroll

An in-depth look at Vesna Krezich Kittelson's early color works reveals an artist's process of questioning both the universality of her personal experience and the intimacy of the human experience, captured on paper in color and gesture. The habit of beginning an artwork with a question started with her color works in the 1970s and continued throughout her career. Vesna's process began with an intellectual or emotional question that she articulated through physical work and the interrelations of color and form. There was no predetermined outcome in her process; the resulting artwork is the evidence of her cycle of questioning. Such explorations often exposed new questions that propelled her art forward. The three stages of Vesna's color work in the late 1970s through the mid-1980s range from poster-sized color field paintings to large gestural explorations to dimensional paper sculptures. These three phases in her early artistic career reveal the significant impact of the Women's Art Registry of Minnesota (WARM), which ultimately launched the artist into a painting practice rooted in a cycle of intellectual questioning and physical processing.

Vesna Krezich Kittelson has been called a woman of elsewhere. She was born in Bosnia and Herzegovina and raised in Split, Croatia, on the Adriatic Sea during Yugoslavia's Communist era, when the equality of the sexes was extolled and abstraction in the visual arts was not widely practiced. The politics of Yugoslavia's Communist regime differed from that of other Communist states, particularly in its relaxed restrictions on religion and art.[1] Growing up, Vesna was exposed to art in museums, and art making was always a part of her life and schooling, but she did not consider art a career option. To satisfy her parents' wishes for her to have a productive career, she studied maritime law at the University of Split (Zagreb), receiving her degree in 1969. The law school at the University of Split gave Vesna a grant that she used to attend Newnham College, a women's college of Cambridge University in England, to supplement her law studies with English language courses. Her life and career took an abrupt turn in Cambridge when she decided to pursue art as a career and to move to the United States. Vesna landed in Minneapolis, Minnesota, in 1970.

THE FEMINIST ART MOVEMENT IN THE TWIN CITIES

During the 1970s in the United States, the pushback of conservative groups and large corporations against the momentum of the civil rights and feminist movements in the 1960s caused both political and social tumult.[2] The Twin Cities in the early 1970s had a very vibrant grassroots activist scene with many organizations and groups dedicated to raising public consciousness, combating inequities, and providing services to underrepresented communities. Several feminist organizations surfaced at this time, including Women's Consulting Services, a clinic and health referral service; Amazon (1970–2012), the first feminist bookstore in the nation, which became an epicenter for local feminist groups to meet, interact, and rally; and Women Historians of the Midwest (WHOM, 1970–2001), dedicated to encouraging women historians and unearthing women's stories throughout history.[3] Colleges and universities of the Twin Cities contributed to this lively environment through student organizations and by hosting nationally recognized speakers who addressed issues of social justice.

A talk by Judy Chicago on April 4, 1973, at the University of Minnesota became a catalyst for the feminist art movement in the Twin Cities: this event would inspire the founding of the Women's Art Registry of Minnesota (WARM).[4] WARM began locally from a confluence of the activities surrounding the national feminist art movement, which directly stemmed from the women's movement that began in the 1960s (today referred to as second wave feminism). Women's collectives, galleries, publications, and slide registries were started first in Los Angeles and New York, then spread across the nation. WARM's purpose was to exhibit Minnesota women's art and to provide a platform of support for women artists.[5]

In the beginning, the fledgling group met in the living rooms and kitchens of its members—sharing, discussing, gathering consensus, planning, and organizing. Assembling a slide registry and finding places to exhibit the art of its members became WARM's first priorities. The group quickly grew from a handful of women artists to more than fifty members. WARM went on to create the nation's largest women's collective gallery in downtown Minneapolis, which was in operation from 1976 to 1991.[6]

Vesna arrived in Minneapolis during this rich time of development and support for feminist artists in the Midwest. She observed the feminist activities at this time with curiosity but did not partake in them—she had been brought up to believe in equality of the sexes in accordance with Communist propaganda. Within her first weeks in her new hometown, she enrolled in the University of Minnesota and was welcomed into the university's art community. Here she received formal training in art, culminating in an exhibition at Coffman Memorial Union in June 1974 titled *Mediterranean Cycle*; she acquired her bachelor's degree the same month.[7] Shortly after, Vesna enrolled in the graduate school of design at the University of Minnesota, where she worked with notable Minnesota artist Eugene Larkin.[8] Her graduate work focused on a single element of visual experience: the behavior of color. Her graduate thesis, *Unity of Complements*, outlined her goal of finding overall harmony using oppositional elements: the fields of complementary colors played on one another yet achieved an overall unity. The artworks that contributed to her thesis were included in four exhibitions across Twin Cities college campuses and two Minnesota State Fair fine art exhibitions.[9] She graduated in December 1978 with a solo exhibition at the University Art Museum.[10]

PHASE I: COLOR FIELDS SERIES

During her studies in the design program, Vesna experimented with many ways in which color interacts with itself, finding that even this single visual element could produce limitless outcomes. Her work in the late 1970s, in a similar vein as Josef Albers's decades-long color series *Homage to the Square*, limited the formal elements to horizontal bands of color within a horizontal rectangular frame. Like a window, the size and frame of this series encouraged associations with exterior landscapes and horizon lines. While there is little trace of the artist's hand, there was a physicality to the layered colors. Vesna worked on a tabletop with printmaking inks, brayers, and heavy paper. She applied color with a brayer through stencils and masks, often building up layers. Hidden within these stark formal elements is the beginning of her process of answering the artist's intellectual questions (in this case, how colors interact) through physical work.

Although not illegal in Communist Yugoslavia at the time, abstract art would not have been encouraged or supported. In the United States, an artist was free to experiment, and abstract expressionism and minimalism were already established in culture and art education. Applying Minimalist formal rules, Vesna's exploration seemingly stripped away the details of humanity—no marks, no individual, no gender, age, or nationality was necessary or apparent—leaving her free to delve into the interaction of color with itself. She did not strictly adhere to a single method or movement in art but rather drew from the many influences that resonated with her. The initial questions of pure color would gain layers and complexity as her emotional and cultural correlations to color grew into questions of association and representation. Against a Minimalist grain, Vesna's life experiences would sometimes be reflected in her color field paintings, by abstracting representations into bands of color. The artwork *Christa* (1979), in bands of bright summery pastels, is a portrait of a young girl who loved sorbet.[11] Another example, *Design, French Interior (Rose and Green)* (1977), reflects her impression of French buildings—hard on the outside, soft on the inside—recalling her time living in Paris in 1977.[12] *Yellow and Blue* (1979) was titled with only primary color names, but the actual colors of the composition were much more complex, containing nuanced values and chroma. This composition would seem

Christa, 1979
Oil-based printing ink on paper
26¼ × 40 inches

to imply a landscape of hazy sky over water and sun-bleached sand, darkened by waves where water meets land. Most of the titles in this series state only the dominant primary colors of the compositions, which removed the artist's personal experience, leaving viewers open to make their own associations. Vesna continued this exploration of banded color interactions until 1980.

THE IMPACT OF WARM: NEW QUESTIONS

After she graduated in 1978, Vesna began to search for galleries to represent her art. At the suggestion of Mari Lyn Ampe, a friend whom she had met in graduate school, Vesna applied to become a member of WARM: A Women's Collective Art Space, often referred to as the WARM Gallery, which had opened in the spring of 1976.[13] The application process was rigorous and included a formal written application with slides and a presentation-cum-interview. Like all applicants, Vesna was evaluated not only on the merit of her artwork but also on the possible professionalism she could bring to the organization as well as the potential benefit gallery membership would contribute to her career.[14] Vesna's application was accepted, and she began her WARM Gallery membership in 1979. She remembers that "this period was without any question the most significant time in my art career. During the WARM years, I gained ideas and the courage to explore how to become a woman artist, and why to be a woman artist, for a lifetime."[15]

In contrast to the Communist ethos of her homeland, WARM became Vesna's formative experience with democratic ideals. In an interview, she recalled, "For me, America started with WARM" and the activities of this group were like "a graduate school of life."[16] WARM meetings, which often lasted many hours, included consciousness-raising practices, consensus building, and voting, which Vesna found incredibly engaging; these activities epitomized the artist's understanding of democracy. While the studio work of gallery members demonstrated a broad array of media and methods, Vesna discovered that several gallery members (including Sandra Kraskin, Mari Lyn Ampe, Jane Starosciak, Vicki Johnston, and Mary Walker, among others) worked in similar realms to her own: color, geometrics, pure abstraction, and minimalism. Vesna found in WARM a supportive platform and community in which to continue her artistic exploration.

Vesna participated in the WARM Gallery's annual members group exhibition just months after joining. Her first small group exhibition with Susan McDonald and Joyce Lyon followed a short time later in January 1980, where Vesna's color field works were shown. At the WARM Gallery, it was a common practice for exhibiting artists to give a casual public introduction of their works on display. Vesna internalized the experiences of working and interacting with the artists of WARM, which led to new ideas and new questions. She began to think about how to bring dimensionality to the color field paintings and how to use brushstrokes as gestures to build a new visual language. She started to ideate about "the intimacy of the human body in an abstract sense."[17] She saw many of the same issues in the work of Judith Roode, which Vesna found interesting to contemplate. These new ideas and questions signaled an imminent change in Vesna's studio work.

PHASE II: COLOR FIELDS AND GESTURE

Spurred by a new line of questioning, Vesna began to move away from strict Minimalist methods to explore aspects of abstract expressionism. This new interest in gesture and mark entailed a method of physical work that required the entire body and implied a scale Vesna had not previously explored. Vesna's workspace moved from a tabletop to the wall, still in a horizontal format on large sheets of paper in the range of four feet by ten feet. With the freedom of scale, the question was now how to bring the gestural brushstrokes to the color field paintings. The first work in this evolution, *Lavender Field* (1980–81), is a contemplative layering of repetitive, rhythmic mark-making in shades of pale lavender, seafoam, and lime green, with pops of tomato red and deep dark purple. Like strands of color blown in the wind across an open field of vertically washed lavender, the work revealed Vesna's physical process: the movement of her hand, arm, and body in answer to the question *What is a color field with gesture?* The last work in this series, *Red Field* (1980–81), similarly evidences the artist's corporeal explorations, with its warm, bright sparks undulating across a luminous red-orange wash. The works in this short-lived second phase of Vesna's color exploration are like a *pas de deux* between artist and artwork—a dance of gestural marks, large and small, repeated and layered, back and forth across the expanse of the paper.

To facilitate working in this larger format, Vesna did something that would bring unforeseen freedom and an explosion of new questions: she ordered a 100-yard roll of Arches watercolor paper. This began the third phase of her color work. Vesna dove into the expansive possibility of the paper roll, working on the floor to apply acrylic paint in layers of color. She recalled that she became "brave with the brushstrokes and the energy"[18] and that working on the floor over the piece was a whole-body experience. Fields of color are still prevalent in this phase but are no longer confined to bands or rectangles. The gestures were no longer separate, individual strokes but heavily worked, overlapped and intertwined like mesh. Not unlike the luminosity in Mark Rothko's later color field paintings, the texture of Vesna's paintings glowed with layers of similar colors, each worked over one another in semi-transparency and with repeated, small, gestural marks.

While this layered luminosity of color may have been a natural next step, the most significant departure of this phase is how Vesna's idea of gesture became a dimensional expression as she folded and cut into flat planes—an expression that could be likened to works of Post-Minimalist sculptors like Richard Serra's arched and folded steel sculptures and the wall-mounted felt sculptures of Robert Morris. The paper in Vesna's work could hold a gesture in space through folds, creases, arches, and waves. Gesture and line were no longer confined to a brushstroke within a rectangle but now included the physical motion of the artist wielding a utility knife or scissors, slicing the rectangular frame and manipulating the planes of paper. The cut edges became part of the composition, the default shape of paper no longer visible; the folds and creases in the paper added dimension that defied encapsulation in a traditional rectangular frame behind glass. The first two series of the third phase of Vesna's wall-mounted color works are titled around the concept of flight: *Gliders* and *Kites*. The idea of flight had many meanings for Vesna at this time: from the feelings of working over the paper on the floor, to the freedom of shedding the rules of previous phases, to the airplane flights of her annual extended trips to Croatia to visit family as well as other foreign and domestic travels.

While this phase of dimensional color works continued as Vesna's primary process for a number of years, it was increasingly representative of bodies, corporeality, and sometimes specific people, who were often made apparent in the titles. The work *Carmina Burana* (1984) was produced and exhibited at the WARM Gallery in 1984. Inspired by the music of the same title, it bears resemblance to a robe draped over outstretched arms with a shimmering gold rolling out of the seam at the center.

In 1987, Vesna's membership in the WARM Gallery came to an end. An opportunity arose for her to live, work, and exhibit as a visiting artist at Cambridge University in England. In accepting this year-long position, the collective requirements of the WARM Gallery could not be met, and there were no mechanisms in place for leaves of absence from the gallery. Once in Cambridge, where her life had taken such a pivotal turn in 1970, Vesna's color work underwent another transformation: the paintings left the wall. Her new question, layered onto color, form, and gesture, was "how to make paper … into a freestanding seven-foot-tall sculpture."[19] These sculptural paintings, such as *A Kiss* (1988), were Vesna's "lyrical representations of human figures."[20] These new artworks were exhibited in 1986 at the Jock Colville Hall exhibition space in Churchill College of Cambridge University and in 1989 at Macalester College in St. Paul, Minnesota.

From her early, restrained color field paintings to the later luminously layered sculptural works, Vesna's artistic process continually questioned the ways in which color and form can represent both the human experience and her own individual life. Deeply rooted explorations of color, form, gesture, and dimension are exemplified in these three series of color works and add a depth of experience to the many artworks she would later produce. In her openness to synthesizing the unfolding events of life into her art, Vesna would often break her own rules; she eventually described herself as a Baroque Minimalist. Her later work would take on a full range in formal elements, mediums, themes, and subjects, often in contrast to one another—like the fields of complementary colors that played on one another yet achieved an overall unity.

Notes

1. Glenn E. Curtis, ed., *Yugoslavia: A Country Study* (Washington, D.C.: Library of Congress, 1993).
2. Heather Carroll, *Roots and Fruits: Exploring the History and Impact of the Women's Art Registry of Minnesota,* exhibition didactic, The Catherine G. Murphy Gallery, St. Catherine University, St. Paul, Minnesota, 2018.
3. Women's Consulting Services Records, Minnesota Historical Society; Stuart Van Cleve, *Land of 10,000 Loves: A History of Queer Minnesota* (Minneapolis: University of Minnesota Press, 2012); Women Historians of the Midwest Records, Minnesota Historical Society.
4. University of Minnesota News Service, *Press Releases, April–June 1973.* Retrieved from the University of Minnesota Digital Conservancy, http://hdl.handle.net/11299/51872.
5. *Meeting Minutes, 1975–76,* Women's Art Registry of Minnesota Records, Minnesota Historical Society.
6. Ibid. Although early membership records are scarce, the first two years of WARM's membership included Diane McLeod, Susan Fiene, Lynne Lockie (the three founding members), Marilynn Anderson, Mari Lyn Ampe, Dee Axelrod, Beth Bergman, Hazel Belvo, Elizabeth Erickson, Ardys Ferman, Carole Fisher, Joyce Lyon, Dorothy Odland, Patricia Olson, Quimetta Perle, Bonnie Wagner, Mary Walker, and many more.
7. University of Minnesota News Service, *Press Releases, April–June 1973*; University of Minnesota, Commencement Program, 1973. Retrieved from the University of Minnesota Digital Conservancy, http://hdl.handle.net/11299/57603.
8. Vesna Krezich Kittelson, email message to author, January 2, 2019.
9. Vesna Krezich Kittelson, curriculum vitae, 2019.
10. University of Minnesota, Commencement Program, 1978. Retrieved from the University of Minnesota Digital Conservancy, http://hdl.handle.net/11299/57608. The University Art Museum was located in Northrop Auditorium until 1993, when it moved to a new building on campus and became the Frederick R. Weisman Art Museum.
11. Vesna Krezich Kittelson, discussion with the author, January 25, 2019.
12. Vesna Krezich Kittelson, email message to author, January 3, 2019.
13. Kittelson, discussion, January 25, 2019.
14. Marilynn Anderson (artist and WARM member), discussion with author, December 9, 2018. This discussion occurred with Beth Bergman present at an oral history event at the Catherine G. Murphy Gallery, St. Catherine University.
15. Vesna Krezich Kittelson, email message to author, May 8, 2019.
16. Kittelson, discussion, January 25, 2019.
17. Kittelson, email, May 8, 2019.
18. Kittelson, discussion, January 25, 2019.
19. Kittelson, email, May 8, 2019.
20. Ibid.

Design, French Interior (Rose and Green), 1977
Oil-based printing ink on paper
18 × 26 inches

Yellow and Blue, 1979
Oil-based printing ink on paper
22 × 36 inches

10

Blue and Orange, 1978
Oil-based printing ink on paper
18 × 24 inches

Lavender Field, 1980–81
Painting, acrylic on paper
42 × 144 inches

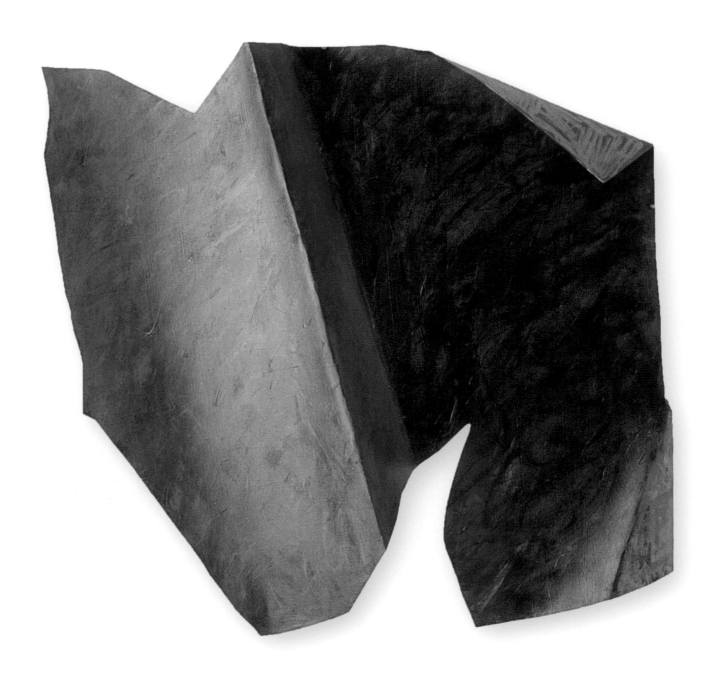

Glider I, 1982
Sculptural painting, acrylic on paper
40 × 40 inches

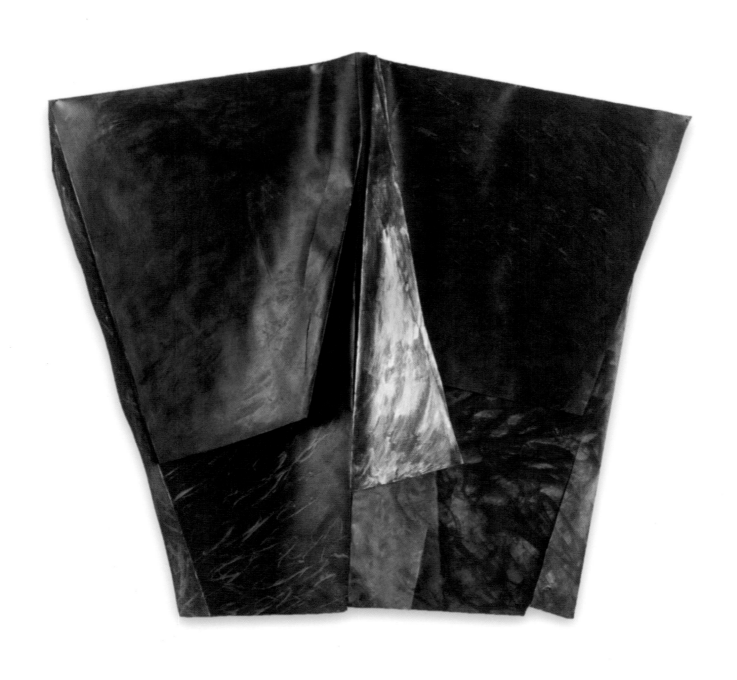

Carmina Burana, 1984
Sculptural painting, acrylic and metallic paint on paper
70×77×7 inches

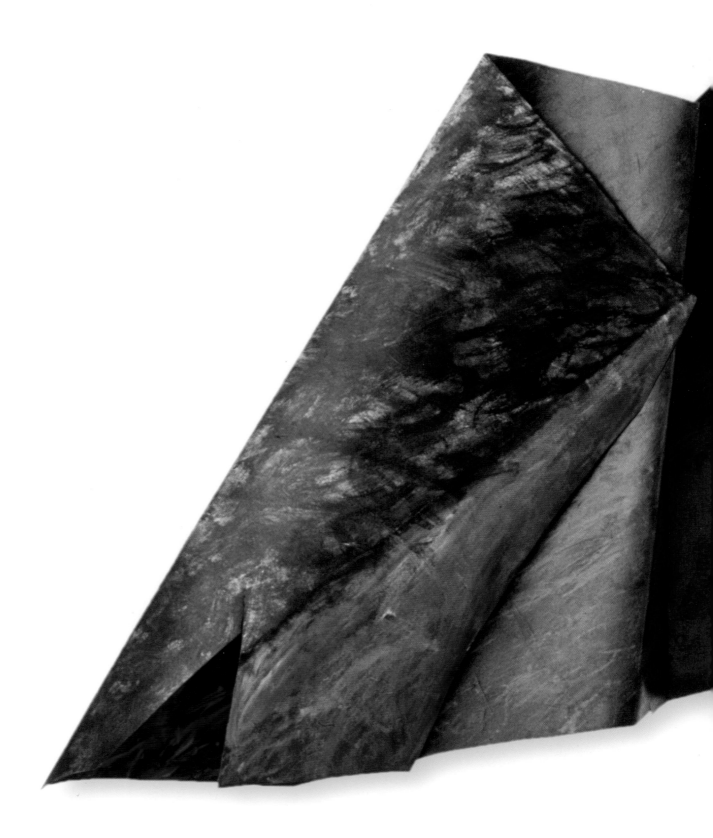

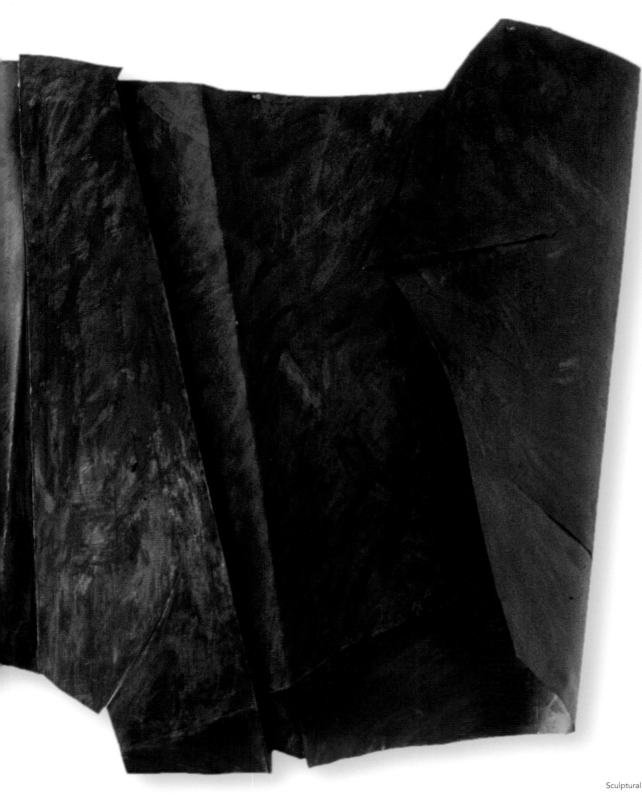

Flight, 1984
Sculptural painting, acrylic and metallic paint on paper
40×73×3 inches

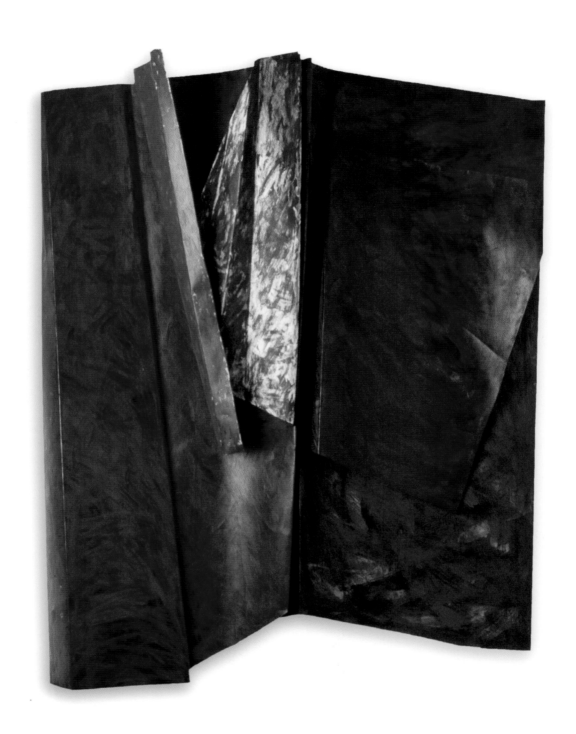

Gates of Secrets, 1985
Sculptural painting, acrylic and metallic paint on paper
80 × 62 × 4 inches

18

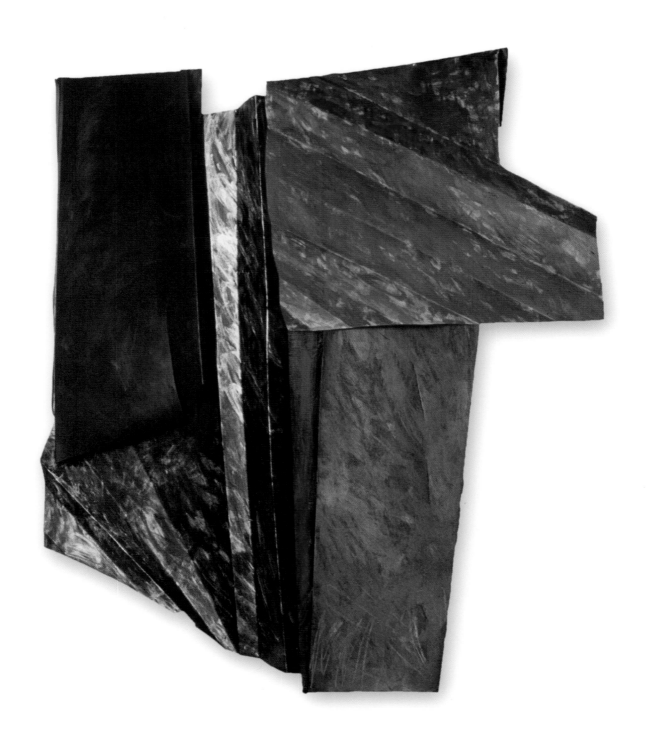

Gates, 1986
Sculptural painting, acrylic and metallic paint on paper
80×74×3 inches

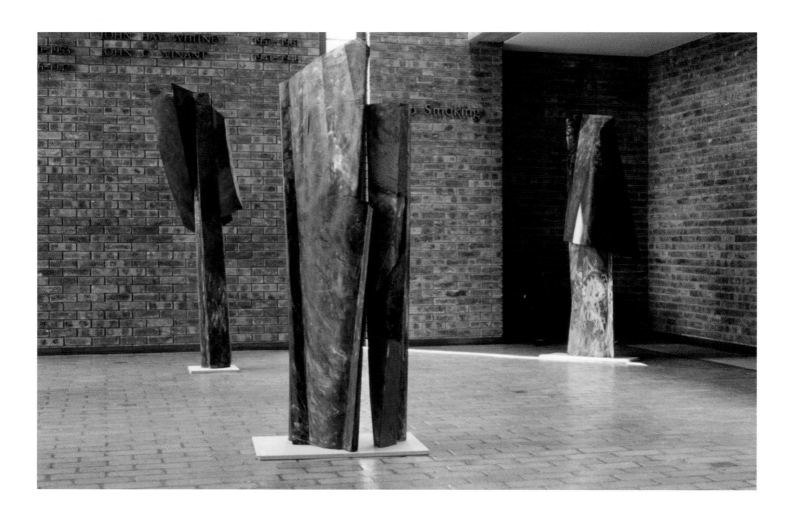

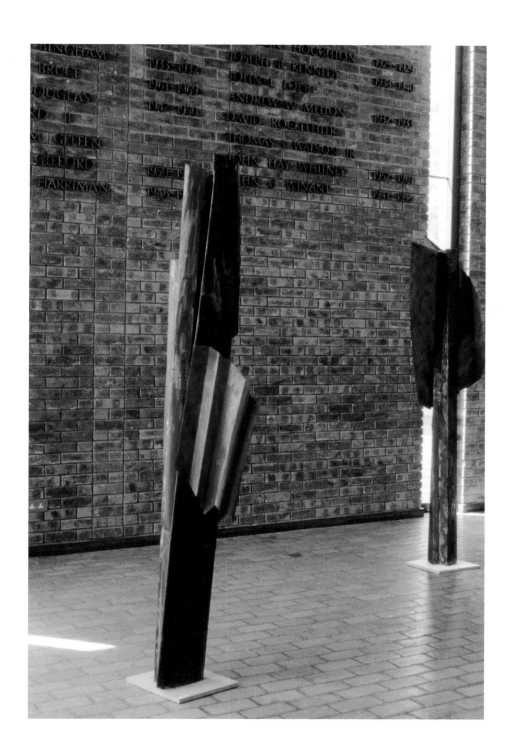

OPPOSITE:
Exhibition view, 1986
Sculpture, acrylic on laminated paper
Jock Colville Hall, Churchill College, Cambridge, England

Exhibition view, 1986
Sculpture, acrylic on laminated paper
Jock Colville Hall, Churchill College, Cambridge, England

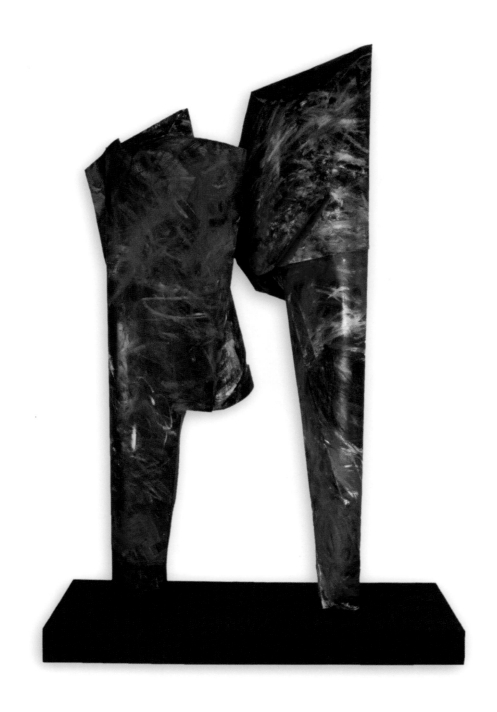

A Kiss, 1988
Sculpture, acrylic and metallic paint on laminated paper
70 × 60 × 12 inches

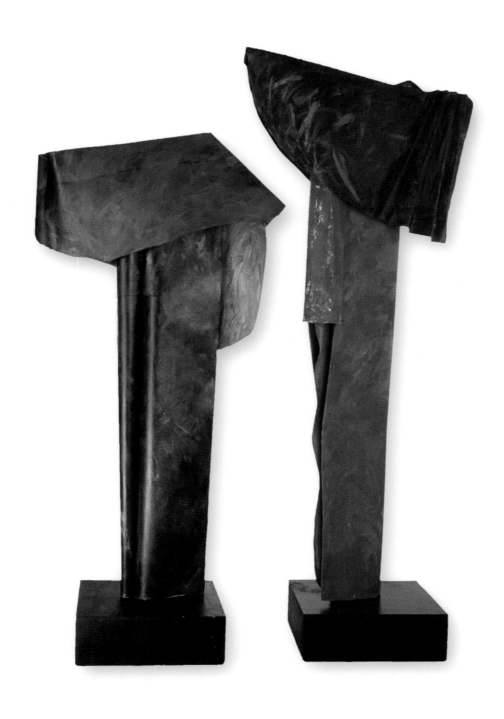

Untitled, 1988
Sculpture, acrylic on laminated paper
70 × 40 × 12 inches

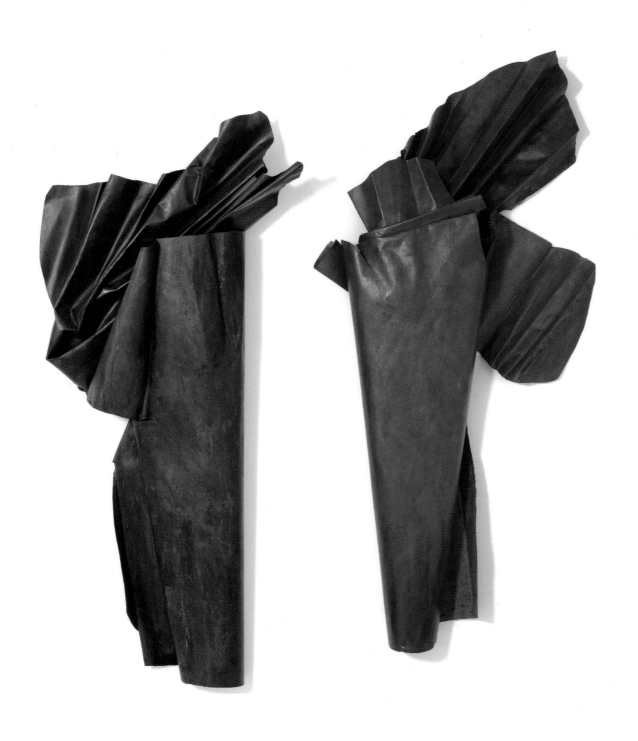

Londoners, 1988
Sculptural paintings, acrylic on paper
Wall installation, 84 × 84 × 8½ inches

WAR PAINTINGS

Wendy Fernstrum

For a puny, three-letter word, *war* exerts unusual power over our emotions. War can erupt at any time, in any place, and battles extend beyond physical boundaries into our collective psyche. Not one of us remains untouched by war.

Vesna Kittelson's series of work focusing on the impact of war began during the Revolutions of 1989 that disturbed the foundation of Communist rule in Central and Eastern Europe and beyond, symbolized by the fall of the Berlin Wall. Although she witnessed the conflict safely from afar, listening to radio broadcasts in Minneapolis, Kittelson experienced the wars as if she were one of the civilians caught in the crossfire. She wondered, *How does war affect civilians? What does it feel like to be one of these civilians trapped in circumstances they cannot change?*

Kittelson's epic painting *Massacre of the Civilians in Timisoara, Romania* (1989–90) is a response to one specific act of violence. In her studio, she heard the radio announce the killing of civilians who had gone to the main square in Timisoara asking the Communist state for the freedom to travel to Italy. The government responded by sending soldiers who shot them. "These people had strollers and lunch bags," Kittelson recalls. "They were just asking for freedom. It was a personal, not a political, act. At that moment, I was wondering what it means to be a civilian in a maniacal system."

Kittelson sensed an unraveling that would extend far beyond the public square in Timisoara. Having established a practice of all-body immersion in her artwork, she responded to the news of the massacre by spontaneously assembling material from her studio, including partially completed portraits, thereby opposing the destruction through creation. Urgency is emphasized with her dynamic brushstrokes. The portraits, pulled from easels and integrated into a new work, transformed into witnesses to chaos.

This intense energy, unleashed by devastation, echoes that of Pablo Picasso after he saw photographs in the newspaper of the destruction of Guernica, Spain, in 1937. Bombs had been dropped on a market day when civilians, predominantly women and children, had gathered in public squares. Hundreds were killed. Living in Paris at that time, Picasso responded by painting *Guernica*, a mural-sized piece completed within six weeks. Picasso (one of Kittelson's influences) experienced the tumultuous World War I recovery efforts and the civil war in Spain, where his family resided. Prior to *Guernica*, he had been examining the dark spaces of the human psyche where the seeds of war take root. As a citizen of Croatia, Kittelson, too, had witnessed the powerful reach of those roots from nearby countries.

Another of Kittelson's influences is Max Beckmann, who depicted chaos within and around us. In Beckmann's art, Kittelson recognizes "absolute hell" and the impossibility of maintaining stability within when outside of us buildings and people are bombarded. We hear Kittelson in Beckmann's statement from 1909: "My heart beats more for a rougher, commoner, more vulgar art … one that offers direct access to the terrible, the crude, the magnificent, the ordinary, the grotesque, and the banal in life. An art that can always be right there for us, in the realest things of life." In his expressive

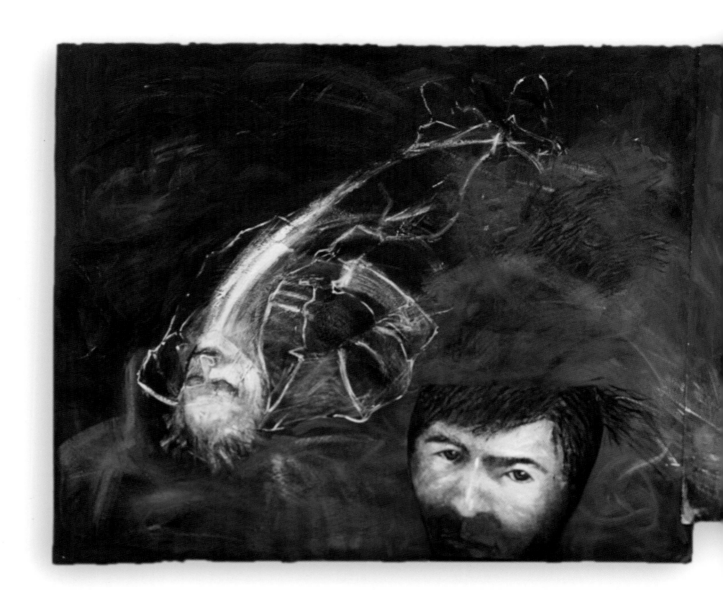

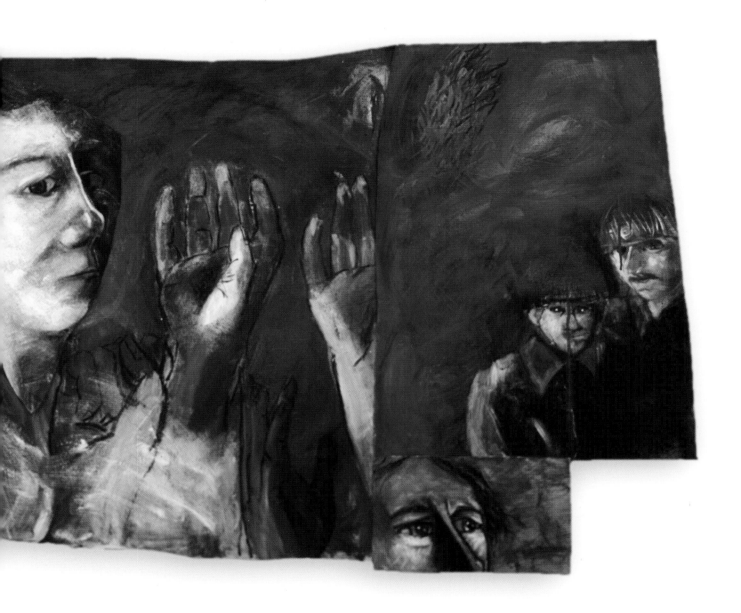

Massacre of the Civilians in Timisoara, Romania, 1989–90
Oil on 3 sheets of paper, brass plate, 2 portraits attached
51 × 122 × 5 inches

images, as well as in Kittelson's, we recognize our own turmoil over the chaos we are powerless to escape.

In her anguish over the impact of destruction and violence on civilians, Kittelson wants to turn away but cannot. The grief she sees in their faces grips her. The horrors are too powerful to ignore. Instead, she responds with paint, holding up for others a depiction of war and its aftermath, as well as a mirror in which we see ourselves. While a photograph documents the destruction, Kittelson's paintings reveal the inner turmoil, the helplessness, the emotional and physical aftermath of violence and destruction. Long after rain washes the blood from the square, the stains of war remain in our psyche. Through Kittelson's work, the blood remains fresh.

Massacre of the Civilians in Timisoara, Romania is an imposing structure that demands our attention. It interrogates our innermost feelings. Look, it says, at the destruction caused by war and warlike behavior. Although this painting is made in response to a particular event, it transcends the specificity of time and place to the universal. It is a witness to the tragedy of humans acting inhumanely.

A pair of disembodied hands, one partially obscured, lifts in a plea for help that is slow to come. Rather than resignation, there is a longing hopefulness in that gesture, a reaching toward some kind of salvation that will end the cycle of violent destruction. Yet the faces reveal doubt of such a possibility. These civilians remain caught between politics and the personal.

Death rests in the dark background to the left, reminiscent of Édouard Manet's *Dead Toreador*, dressed in black. Kittelson's figure dissipates from a painted, solid figure into an unfinished drawing, representing not one particular person but rather everyone who has been killed, signifying things gone terribly wrong. In Manet's painting, blood has only just begun to pool. Kittelson suspends her witnesses in an entire background of vivid red; blood seeps relentlessly into the lives of civilians.

In the right lower corner, opposite death, stand young soldiers, huddled together, conscripted by the government to kill their own people. They, too, are victims of the system. The soldiers stand in for the conflict that stirs within us. By doing nothing to stop destruction, are we complicit in the violence?

What does resistance look like? Do we stand up peaceably or should we respond with our own violence? Too often we simply do what we are told.

As if constructing some kind of understanding of the unthinkable, Kittelson assembled panels of different sizes, shapes, and perspectives to create *Massacre of the Civilians in Timisoara, Romania*. Violence tears us apart. We piece together the fragments, to recover what we lost. Kittelson's paintings challenge us to imagine how we can become whole again. The most famous work of Francisco Goya, another influence on Kittelson, depicts the execution of Madrilenian patriots by soldiers in Napoléon Bonaparte's army during the Peninsula War. While their styles differ, both paintings share an idealism unbroken by war. Goya believed that "the act of painting is about one heart telling another heart where he found salvation."

Kittelson's other works from the *War* series, while much smaller in scale, also rely on portraits to shed light on humanity's shadow side and reveal the turmoil we try to bury. In these self-portraits, the artist represents not herself but rather all civilians. In *Fragile* (2008) we see a face hidden by an arm raised half-heartedly over a skull. As death peers into our fragility, we avert its gaze, sinking deeper into fear and sorrow. The buoyancy of the balloons counters the weight of the boulder-like hanging head. The tenuous balance of hope and despair tips either way, depending on the moment. Strings join the two states of mind in a larger collective.

War (1991) reveals the darkness of destruction. Sorrowful eyes gaze directly into ours from behind a veil serving as protector. As in other cutout self-portraits, an abstract, folded shape with gold undertone rims the portrait, framing the expression. In *War*, the woman leans into the folds as if for support when so much has crumbled. The veil and the folded shape serve as opposing forces, with vulnerability caught between, like a fish in a net—not free, yet still swimming.

Impact—9/11/2001 (2006) is comprised of three cutouts, all responding to the attack on civilians in New York City and the aftermath. Subtitled *See No Evil, Speak No Evil, Hear No Evil*, each cutout examines the impact of violence on the human psyche. In *See No Evil*, the woman appears to be in a

state of unconsciousness, her mottled skin belying any sense of peace. *Hear No Evil* shows the woman in a despondent state, blocking out the screams of people and sirens during the attack and the analysis broadcast afterward in a torrential stream. In *Speak No Evil,* we see the symbolic gesture of hands to face as one witnesses a catastrophe. What are the right words to say after an act of violence? Does speaking angrily and with hatred for the attackers contribute to evil?

"All of my work is based on a very big premise," explains Kittelson. "How can I show humanity's dark side—people destroying and harming—and its light side—people building schools and parks, writing poetry, making art." An avowed colorist, she relies primarily on hues to convey this dual nature, but she also weds representation with abstraction. As a counter to darkness, the brass panel in *Massacre of the Civilians in Timisoara, Romania* and folds of gold at the top of some of the cutouts shine with undefeated optimism.

Stripped of context, the cutouts appear as fragments the viewer can piece into her own experience of war. Kittelson's familiarity with fragments arises from her childhood in Split, Croatia, where architectural remnants of civilization as far back as the Roman Empire coexist with glass and neon. The cutouts form a vocabulary that instigates an open-ended dialogue with viewers who choose their own backdrop. We try our best to make sense of the nonsensical.

Related to the trio of cutouts of *Impact—9/11/2001* is the group of paintings on wood panel squares, collectively called *War Insomnia* (2006). This substrate allowed Kittelson to arrange the portraits against a somber background reminiscent of Goya, though not quite as dark. Each figure is suspended in the unknown, searching for light, if only a glimmer. The left panel, *War Insomnia,* speaks to the underlying anxiety caused by war regardless of its geographic distance from us. Kittelson's paintings shatter any illusions we may have about being insulated from destruction happening outside our cozy living room. Pretending immunity is a form of sleepwalking. When we drop the illusion and allow ourselves to feel the anxiety, insomnia ensues. War triggers a watchfulness, a wakefulness, in the civilian caught in the crossfire. In the middle panel, *Goodnight Darling,* two figures console each other in a ritual, loving embrace, yet in the expression on the figure

facing us we see the truth beyond the momentary relief: war rages on, fueled by hatred. The third painting of the triptych, *Undone,* reveals the emotional upheaval caused by the destructive actions of others.

A root cause of war is miscommunication. Kittelson's altered book sculptures titled *Tower of Babel* respond to the question *What happens when there is miscommunication?* This work explores miscommunication at the political and personal levels, where language is used as a manipulative tool, twisting the meaning of words to their advantage. With the understanding that each community identifies with a specific language, Kittelson altered dictionaries of various languages to create a new shared vocabulary that recognizes commonality and differences. From beneath the tarred surface rises optimism. "We should alter ourselves to communicate better," Kittelson explains, "to include others, to create connection."

When Kittelson began her *War* series, she mistakenly assumed that in a democracy the government would not use its power to kill civilians. Now she recognizes that war is universal, its darkness ever present. As wars rage outside us, as well as within, Kittelson challenges us to alter ourselves so we can see beyond the differences. Let us sing, not scream. Let us piece together the fragments to create a new whole.

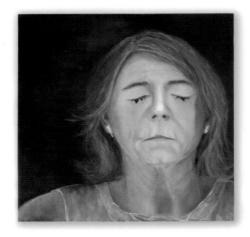 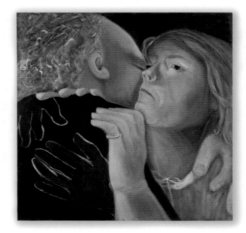 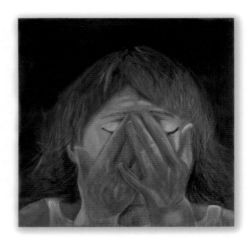

War Insomnia, 2006
Oil paint on three wood panels *(War Insomnia, Goodnight Darling, Undone)*
24 × 24 inches (each panel)

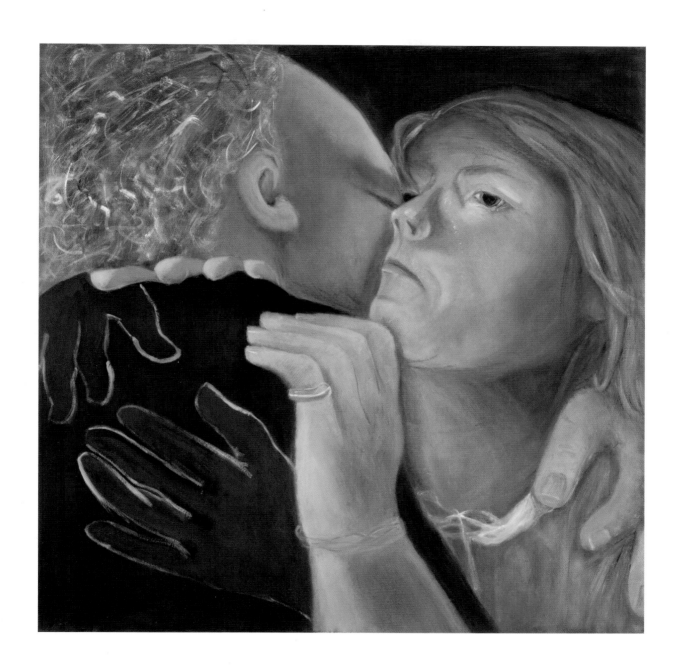

Goodnight Darling
War Insomnia, middle panel

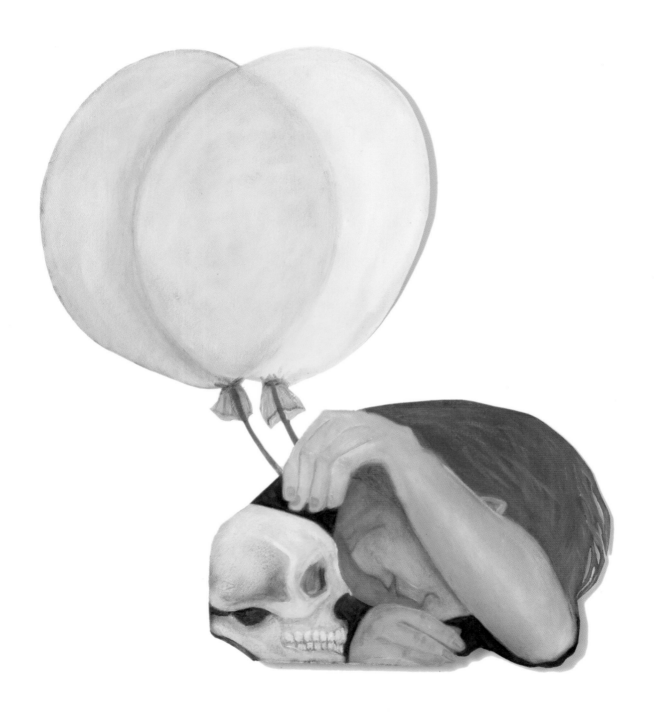

Fragile, 2008
Oil and art crayola on paper, cutout
33 × 28 inches

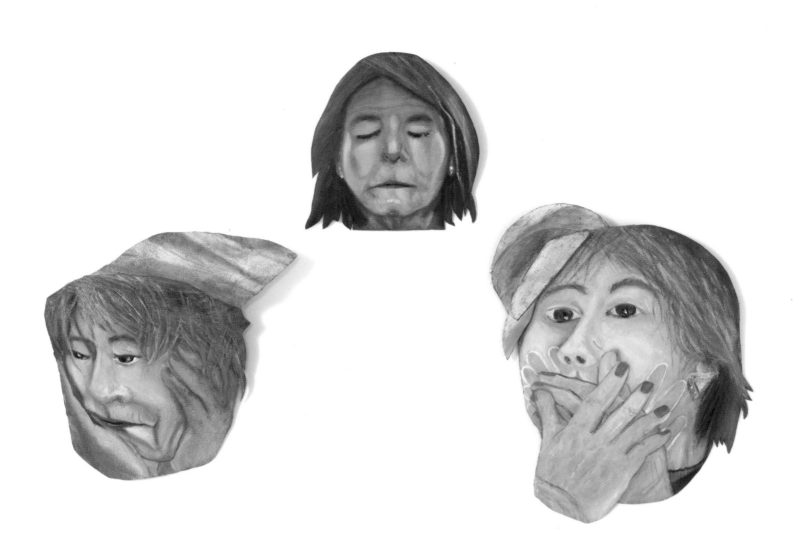

Impact—9/11/2001 (See No Evil, Hear No Evil, Speak No Evil), 2006
Acrylic, oil, and metallic paint on paper, three cutouts
Wall installation, 70×40×3 inches

35

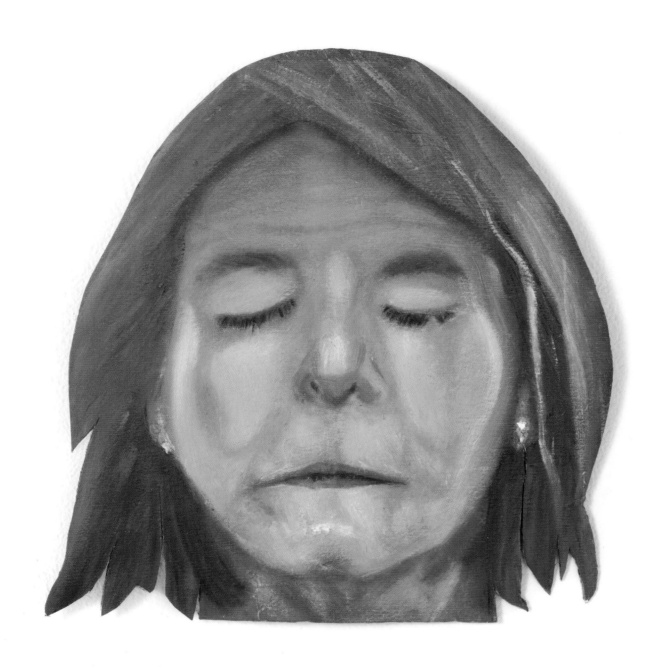

TO CATCH THE FACT

Vesna Kittelson's Self-Portraits

Camille LeFevre

She challenges you to look, as unflinchingly as she has, not merely at her face. Not only to the painted textures and crinkles, fullness and hollows of her face but to her countenance. To the distinctive physiognomy of the Croatian-born artist's visage, with long nose set firmly at its center. To the dark eyes, boldly gazing back at you. To her lined upper lip arching tightly above the slightly cleft chin. To her complexion rosy from the sun, wan with fatigue, or casting both shadow and light. To an inscrutability that, nonetheless, invites investigation.

Nearly always, she is looking forward, forward-facing, without excuse or apology, with nothing to hide. Her hands reach up to pull at the skin beneath her eyes, to press her cheeks back toward her temples, grasp her face in a pensive embrace. A single hand applies a vibrant red lipstick to her mouth, or an index finger grazes the length of her cheek with the rest of her hand curled around her chin. She is unafraid, inquisitive, even if her eyes are closed, lips drawn together.

In one self-portrait commemorating her sixtieth birthday, she glances askance behind fashionable red glasses. A slight smile animates her features, her fist propping up her chin, balloons floating about her head like thought bubbles in which the memories flitting across her face are invisible yet captured. In another, her lips are pursed and nostrils pinched as she holds the balloons in thoughtful consideration. In a third, the red and yellow balloons float in stark contrast to her head lying heavily in the crook of her arm, a skull resting beside her.

These self-portraits are not simply moments or gestures in time. They are documents of a life being lived with emotion and intelligence. Of a woman quite literally facing the aging process, the process of her aging and of every woman's aging. Of a woman artist comfortably questioning her appearance in youth-obsessed American culture with strict definitions of beauty. Of an immigrant woman artist, who grew up amid frescoes, painting with the textural technique of her predecessors. Of an experimental artist, who grew up amid fragments of Roman art, editing her finished self-portraits with a pair of scissors into unframed snippets of a life.

Of an artist combining representation and abstraction to create an unprecedented form of self-portraiture. Of a painter acknowledging art historical precedents with a cap or headpiece à la van Eyck's turban or Goya's fan; with eyes, nose, and shoulders slightly askew in the style of Picasso; with butterflies alighting her neck and mouth like a symbol-rich Kahlo; eyes wide with the psychologically charged drama of a Marlene Dumas or outlined in bright white akin to a Cindy Sherman character; with her head bent back in peaceful submission under her husband's kiss, by way of Klimt. She is a woman loved. She is an artist living a supported and expansive life.

In our age of addiction to smartphone-produced selfies, some viewers of Vesna Kittelson's self-portraits might attempt the visual equivalency of the scroll or swipe, inured by hours spent surfing a social-media stream of the nondescript. Kittelson's self-portraits require more; actually, they request your attendance. Here is the self-portrait as artistic innovation, as a conflagration of cultural influences, as art historical past alive in the present.

In his book *The Self-Portrait: A Cultural History*, historian and art critic James Hall traces the origins of the self-portrait from the earliest myths of Narcissus and the Christian tradition of "bearing witness" (singling out St. Dunstan's portrait of himself praying, from the tenth century AD) to the prolific and digital self-image-making of today. Hall argues that a coherent starting point for self-portraiture is the Middle Ages "because it was an age preoccupied with personal salvation and self-scrutiny."

Other art historians point to the Renaissance as the birth of self-portraiture, an era in which the concept of Individualism took hold. Mirrors were created at this time, allowing people to physically see themselves. Mirrors, too, then became a tool for artists—a way to reflect on oneself and one's visage, giving rise to a long tradition of self-portraiture.

For Kittelson, self-scrutiny lies in the expressive content of her self-portraits, the unapologetic fact of her intelligence and emotional existence, which she layers—or rather aggregates—by means of her inventive form, her cutouts. This tool or mirror, through which she presents her moments of self-reflection, involves excising the frame, to reveal and put forth a distinctive sense of self. What we see, what she sees in herself, is a citizen of the world, rooted in the female immigrant experience, living without traditional boundaries. She conflates form and content: they are inseparable and wholly autobiographical.

Kittelson grew up in the ancient Roman city of Split in Croatia, amid fragments of ancient cultures expressed in portions of sculpture, shards of mosaics, spalling frescoes—tantalizing bits of faces, hands, feet, clothing. For her, as a child, this artful paleohistory of everyday life was "electric" and posed "compelling riddles to solve." Similarly, she recognized much later, painting just a portion of her body created opportunities for viewers to fill in the rest, should they so choose; she would create a puzzle of her own for viewers to complete.

Her years spent living among and exploring Split's aesthetic archaeology, mostly made of stone, gave her the courage to work with only a face fragment in her painting practice—including in her self-portraits. Progressing this influence further, she decided (after done with painting her face on paper)

to cut out the image with scissors, following the edges of her hair, the contours of her face, the folds of her hands—"to catch the fact," she has said.

Her frameless face, or even an iterative composition of self-portraits conveying an array of expressions and thoughts, when mounted on a wall, could be read as a collection of fragments: an aesthetic archaeology of Kittelson's own singular life. Positioned in relief, an inch or so away from the wall, they have a three-dimensional, sculptural, even animated affect. They observe not only the spectators viewing them but also their other selves in reflective contemplation.

If painting is a way in which artists express the world as they see it, experience it, then self-portraits turn this outer look inward. In his book *Ways of Seeing*, art critic, novelist, and painter John Berger, after studying Rembrandt's self-portraits, says, "He had to see himself as a painter in a way that denied the seeing of a painter. This meant that he saw himself doing something that nobody else could foresee."

In Kittelson's self-portraits, we can foresee the child amid the ruins, marveling at lives lived through bits and pieces of artistic archaeology, becoming the established and exhibited artist she is today. We can see inclination set, then cultivated through education, then developed through decades of practice in various media (including painting), and finally inspiration sparked by a return to one's origins. We also see in her self-portraits individually, but moreover in assemblage, a reflection of a complex, contemporary life.

Fragments of an artist's psychological, physical, intellectual, and emotional investigation of self; of a life underscored by cultural and political conditions; of an aging woman artist traversing societal expectations and self-regard with a sharpness of mind tempered by love. We see the world as it looks and feels, both full and fragmented. Cumulative. With scope, depth, humanity. "We do not feel the limitation of expectations," Kittelson has said of today's painters working in self-portraiture. For Kittelson, that's a fact.

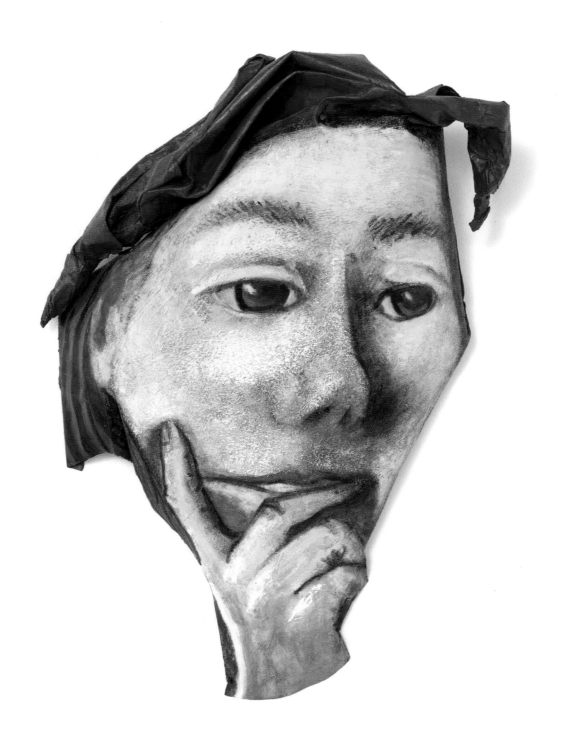

Hesitant (Self-Portrait with a Hat), 1992
Acrylic on paper, cutout
33×25×8 inches

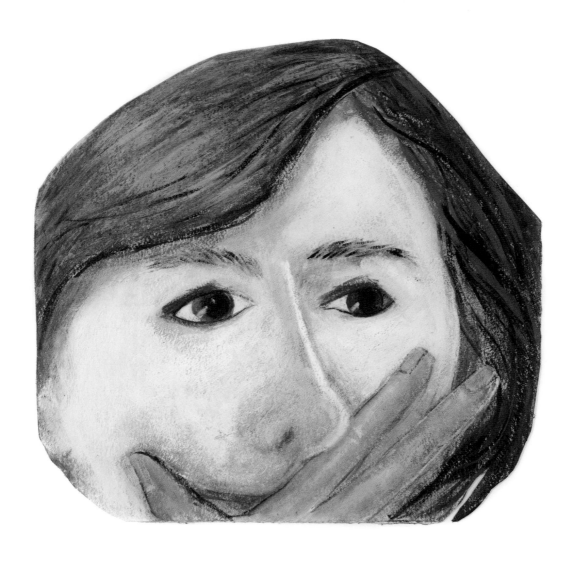

Hesitant (Self-Portrait), 1994
Acrylic on paper, cutout
22 × 22 inches

42

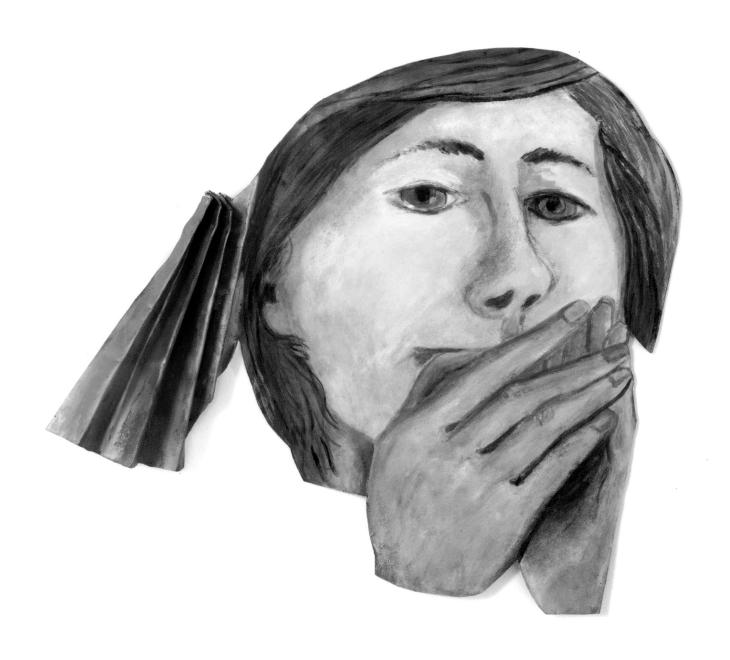

Hesitant (Self-Portrait with a Fan), 1994
Acrylic, metallic paint on paper, cutout
23½ × 25 × 2 inches

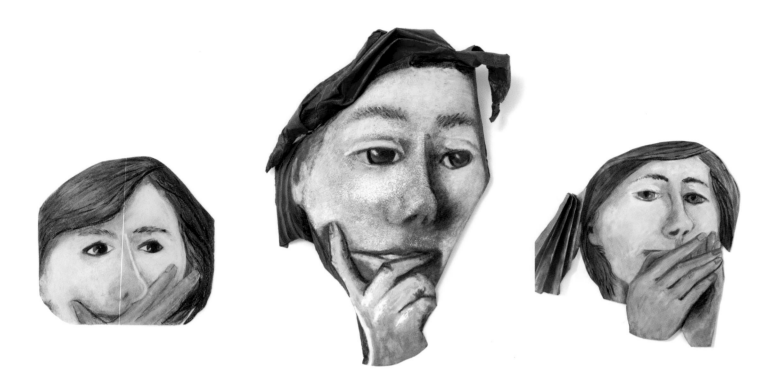

Hesitant, triptych, 1994
Acrylic on paper, metallic paint, three cutouts
Wall installation, 80 × 96 × 7 inches

44

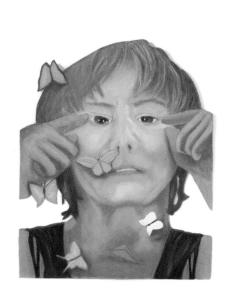
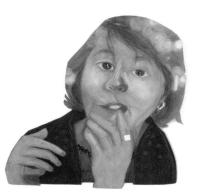
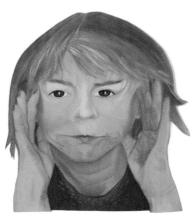

Aging Anxiety, triptych, 2007–9
Acrylic on paper, silver leaf, three cutouts
Wall installation, 96 × 80 × 1 inches

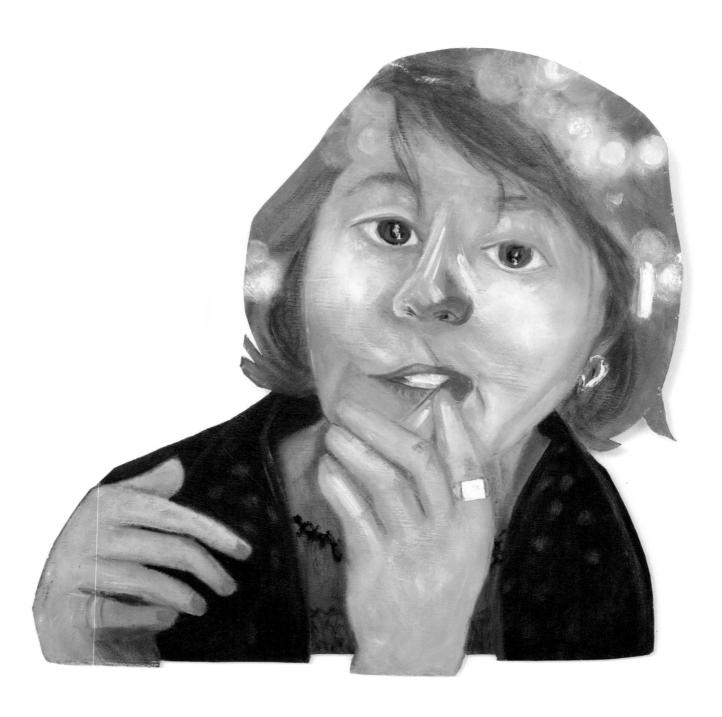

Lipstick, 2007
Aging Anxiety, detail

46

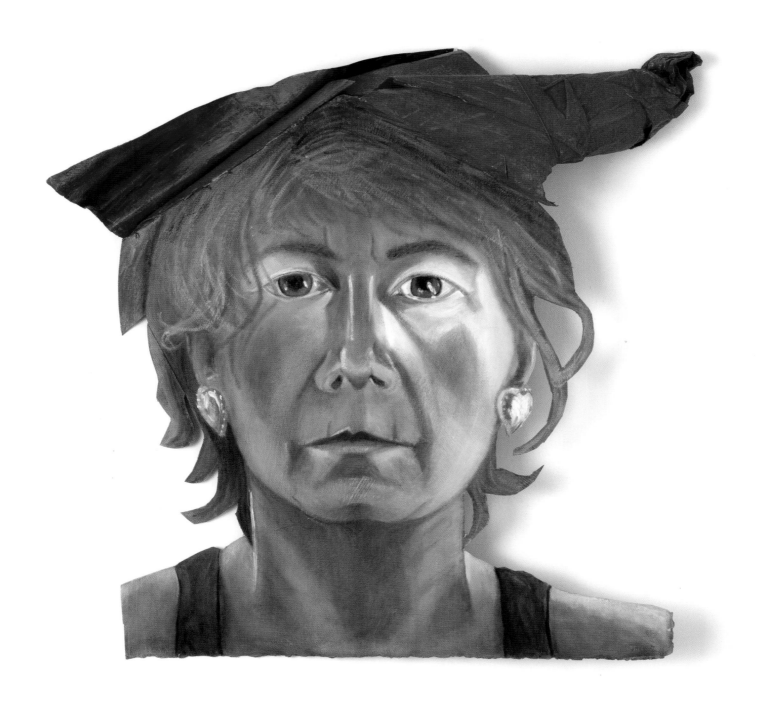

Portrait with a Red Hat, 2006
Acrylic and oil on paper, cutout
25½ × 26 × 4 inches

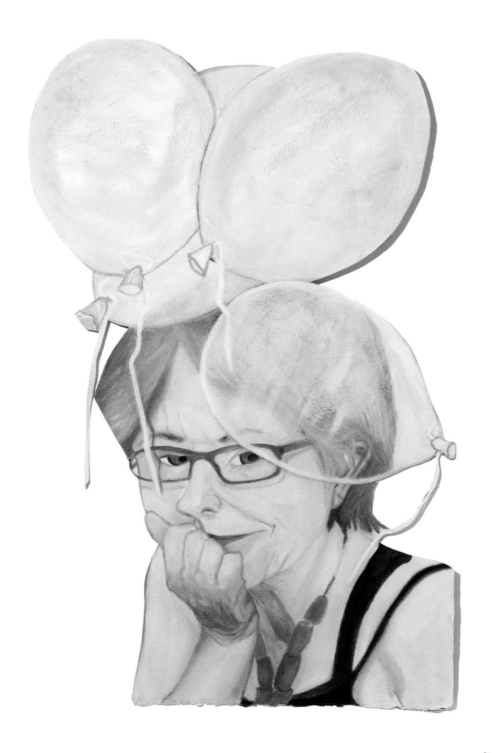

Birthday Celebration with Balloons, 2009
Oil on paper, cutout
41½ × 25 inches

49

Renaissance adds WAM

Young Americans

Ideas

oil painting

Renaissance Portraits

B Roman sculpture Ancient marbles
VAM

D mocracy

YOUNG AMERICANS

Susannah Schouweiler

Upon entering Vesna Kittelson's North Loop Minneapolis studio, you notice that her space is populated with the faces of *Young Americans*. The painted portraits, slightly larger than life, are unfettered by frames and hung directly on the wall, most of them at eye level or just above. You can't help but meet their gazes; most are looking straight on. Their features and apparel reflect a wide range of backgrounds, but they are, unmistakably, individuals, not cultural proxies. They are beautiful, in the way young people always are: each face unmarked by time and experience, glamorous in their youth.

Scan the room, and *Lulu* arrests your attention. The portrait's subject is an African American young woman, a Somali immigrant. Her expression is unsmiling, forthright and serious, but not unfriendly. By comparison, her brother's expression in *Harvey* seems boyishly open. With his red and blue hoodie and white T-shirt, thick gold-chain necklace, and diamond stud earrings, he's got that cool look of middle-class American teens everywhere. Nearby, *Jack*, a young Croatian man, looks out coolly as well, his gaze shuttered behind dark sunglasses. *Adam*, an Israeli American, faces the room sidelong, peering into the middle distance with his wild curls pulled back in a messy ponytail. *Areca* looks into your eyes with a glimmer of challenge in her own, no nonsense and unapologetically sober. The mood shifts dramatically with *Christine*, who is caught in a moment of laughter—tongue captured between her teeth, eyes squinting shut and her grin wide; the expression on her face is as vivid as her pink-tipped hair. Look around, and there are many more: *Isra*, with her fringed head scarf and smiling eyes; *Kara*, in triptych, blowing bubbles with her gum, eyes crossed. *Mandy* is luminous, but her expression is shy; in

contrast, *William*'s soulful, downturned eyes are candid as they meet your own. *Maya* chews on her lower lip, as if nervous to hold your gaze, her hair barely restrained by her black-checkered headband. Seen together, the portraits implicate you in their gathering, invoking a sense of community in the space, as if you are meeting strangers at a party.

A child of mid-twentieth century Yugoslavia, Kittelson was raised in Communist territory, but she was weaned on American movies, music, and fashion. Surrounded by the political and cultural turmoil of the Soviet Union, for young Vesna the America of her dreams was more than a place. It was an aspiration—an ideal as expansive and full of promise as a summer's night sky filled with stars to wish on. Her parents were progressive for their time and place and pro-American in their sentiments. In particular, Kittelson recalls, they revered the U.S. Constitution and its Bill of Rights. "Self-determination was unknown in a poor Communist home," she says. "The idea of entering the middle class through achievement and hard work—the opportunity of America—is remarkable." And through the many faces of her *Young Americans* portraits (painted from 2005 to 2013), it is this American dream that Kittelson aims to capture. Geography doesn't matter when it comes to such things, she says. America is an idea, not a place. As one of her subjects, the young Croatian, Jack, said: "We are all Americans on the inside."

The *Young Americans* portraits are all rendered in oil on archival paper, fortified with silk backing for structure. Kittelson is a deft colorist—it's her technical and academic specialty. Her hues are lush, velvet in their saturation. Her skin tones are

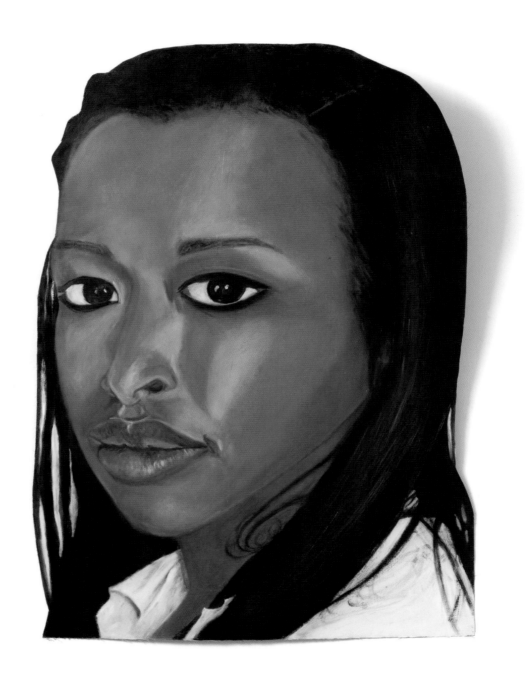

Lulu, 2012
Oil on paper, cutout
25 × 21½ × 3 inches

52

nuanced and radiant, as if lit from within. When asked about her atypical cutout installation of the portraits, she explains: "Framing is a wholly Western convention having to do with property, delineating borders and boundaries. It's a nineteenth-century idea that doesn't resonate with the realities of contemporary life." If we want to learn how to come together, how to hold on to the promise of a thriving, pluralistic society, she says, we have to be prepared to deconstruct outdated mores of ownership and exclusivity. In fact, the act of putting scissors to paper completes the portrait: the raw edge of the cut is the defining line that puts the portrait in direct relation to the viewer. Excised in this way, the faces make the wall a space in the work, a canvas of sorts. Her scissors becomes an existential device, defining new parameters to the world.

Kittelson's formative years were spent in Split, Croatia, one of the oldest continuously occupied cities remaining from the Roman Empire. The ruins of Emperor Diocletian's fourth-century palace serve as the site of Split's bustling "old town" city center today. As a child, Kittelson was fascinated by the commonplace remnants of Split's deep past—Egyptian granite sphinxes, various and sundry bits of statuary. She grew up surrounded by an architectural palimpsest of Roman, medieval, Renaissance, Baroque, and Soviet design and influence. "Given my childhood in such a place," she says, "I've always been comfortable with the fragments of history. A bust feels natural to my eye. I'm interested in the simultaneity of time and tradition—history, present, future, all happening at once, fragmented on one end and united on another."

She is an avid student of European art history. She calls out the influence of early twentieth-century German painter Max Beckmann on her sensibility: "He was a painter who was interested in civilians, not armies—ordinary people victimized by political structures acting upon them." She continues her litany of favorites: "Velázquez, Goya, Picasso—we can't dismiss Picasso! He did busts and fragments, like me, and he also abandoned traditional art techniques." Early on, she says, these artists were central to her own creative growth. "But I've since invented my own parameters for practice, rather than being reliant on other artists' conventions. Mine isn't a practice rooted in preconceptions or inherited techniques; the rules I set for myself were all discovered in the making." She's a self-proclaimed "baroque minimalist—over the top and cut back."

The *Young Americans* series began with a question. Kittelson pondered: What is the most democratic thing about America? "I'm not talking about legal protections and abstract civil liberties," she explains. "I'm talking about the evidence of democracy as demonstrated in daily life—democracy in action." A studio art instructor for many years at the Minneapolis College of Art and Design (MCAD), Kittelson found her question's answer in the stories and faces of the young people she taught on campus, some of them immigrants like her. "I'm astounded by the promise of these young men and women. They have such flexibility and adaptability. They expect the best of themselves and their peers, and see democracy as a plastic medium. I do, too." Young people don't take for granted their creative power to shape democracy, she says. It's not abstract; it's not merely conceptual. They practice it.

Kittelson's *Young Americans* portraits are rooted in conversations. She needs to know her subjects' stories, their point of view on the world, before she can paint them. "My first consideration is that emotional connection, capturing something of the distinctive intelligence of the person I've chosen as my subject." The specifics of capturing their visage come next. And in the process of creating that likeness, the painterly gesture of putting brush to color and paper, she finds "the resonance that will make the image spark." She uses a reference photograph on occasion, but it's much smaller than the finished portrait; she always takes those photographs herself. The photography is, in a sense, her first portrait; she describes the photographs as her "preliminary drawings."

To understand Kittelson's *Young Americans* project, one must first consider the artist's own American story. At twenty-two, as a new lawyer just graduated from law school in her native Croatia, Kittelson received a grant to pursue a deeper study of English at Newnham College for women at Cambridge University in the UK. The child of a seaside community, where most worked, in some capacity, for the shipyards, she had studied maritime law in her homeland and needed to improve her English language skills to be able to draft and negotiate international contracts. At Cambridge she met another international student, a scientist, who would become her husband, David, a Norwegian American from Pelican Rapids, Minnesota.

When he brought her back to America to begin their lives together, Kittelson's trajectory changed. Up to that point, she had imagined channeling her lifelong love of art into collecting, while following a more practical, expected professional career in law. As a brand new American, she dared to dream of pursuing a different path, a life making art herself. Shortly after establishing a home in the United States, she returned to college for her undergraduate and master's degrees in studio art and design at the University of Minnesota. In the years that followed, she raised her son and cultivated her art practice. As her son grew up and her art began garnering more notice, she deepened her roots in the Twin Cities art community: she taught painting as an instructor at MCAD from 1995 to 2009; was a founding member of the Traffic Zone Center for Visual Arts cooperative in Minneapolis; and was a member of the Women's Art Registry of Minnesota (WARM) and Form + Content co-op gallery, among other activities and organizations.

Kittelson's practice is mercurial—unbound to a fixed medium, style, or sensibility. For her, content drives form; ideas inform the structure and composition of her work, from sculpture to artist books, collage, and painting. She's a visceral artist, formally educated and skilled but unconcerned with demonstrations of technical prowess. "I don't care so much about technique," she says. "I'm drawn to open-ended questions: what impacts us? That's what drives me." The lens through which she makes and views her art is irrevocably shaded by the in-between nature of her life as a hyphenated American, the back-and-forth of her identity and cultural frameworks. "I am both a participant and an observer here," she says. And for her *Young Americans* project, Kittelson was drawn to capturing others in her community whose experiences resonated, in some way, with her own.

As an instructor at MCAD, she watched young people from a variety of cultural communities and backgrounds learn how to be together and live side by side, despite their differences. To her, these young Americans embodied the very best of democracy in action, the ideal of American promise and freedom in practice and made flesh. "I got to know such intelligent, thoughtful youth when I was teaching. I wanted to paint them, to capture that intelligence and spirit I saw in them in their portraits."

It all began with Areca, an African American woman who was studying at MCAD for a semester and taking one of Kittelson's classes in advanced painting. She was biding her time in Minnesota waiting for her Norwegian American fiancé, an architect, to finish a project in Marine on St. Croix, a small town near the Twin Cities. Kittelson and Areca were talking one day, and Areca asked what it was like to grow up in Communism. Kittelson offered her a deal: "I'll tell you about that, if you'll tell me what it's like to be a black person in America." Areca described her experience as one of very few African Americans in a well-heeled, small Minnesota town. She told Kittelson about her litmus test for finding allies there: shortly after she and her fiancé arrived in town, Areca baked cakes for her neighbors, and she took a cake to each house, one by one, to see who would answer the door and turn her away and who would greet her warmly. Kittelson told her about life under Communism and related her own experiences straddling European and American life and identities.

After they had shared stories, Kittelson asked to paint her portrait: "She agreed to sit for me, on the condition that I didn't ask her to smile." Areca had worked as a model and said she always felt self-conscious and phony when made to smile for pictures. Kittelson painted her wearing an expression Areca found most natural—no fake smiles, nothing put-on.

Kittelson's subsequent portraits followed suit. She is emphatic about the creative purpose of her deeply personal approach. Her *Young Americans* are subjects in every way, not symbols, objects, or specimens. "My paintings need to capture these young people as breathing, thinking, feeling persons," she says. "I'll cut everything else away in order to get that."

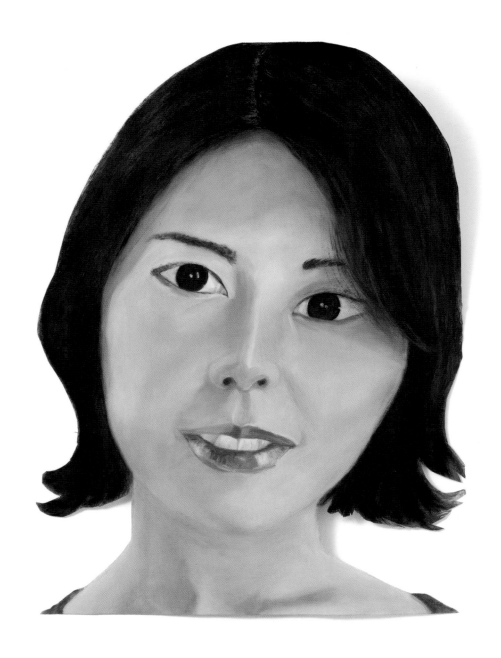

Rica, 2011
Oil on paper, cutout
30 × 22 × 1 inches

55

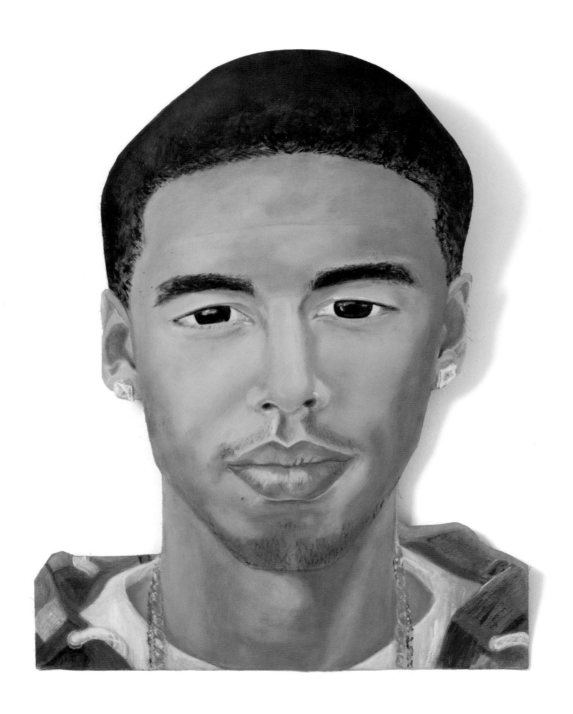

Harvey, 2012
Oil on paper, cutout
25 × 23 × 3½ inches

56

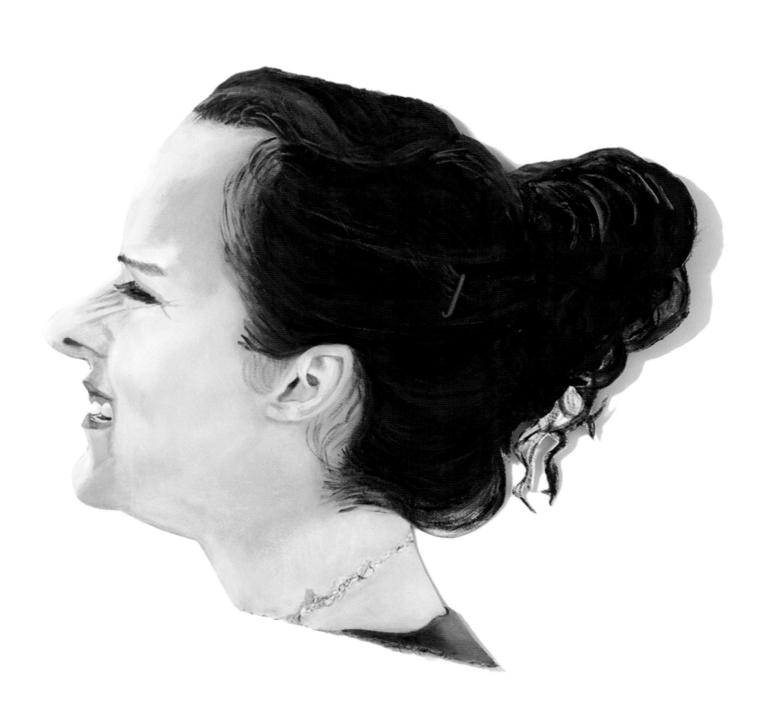

Annie, 2009
Oil on paper, cutout
28 × 28 × 1 inches

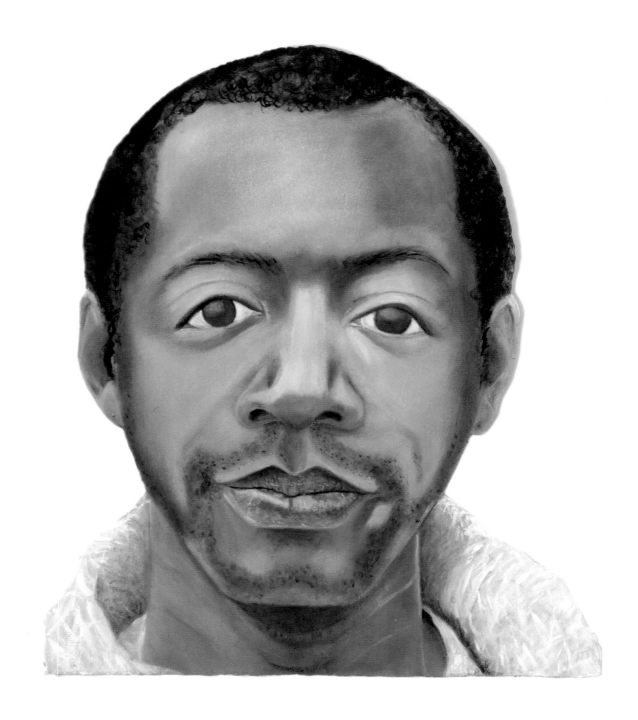

58

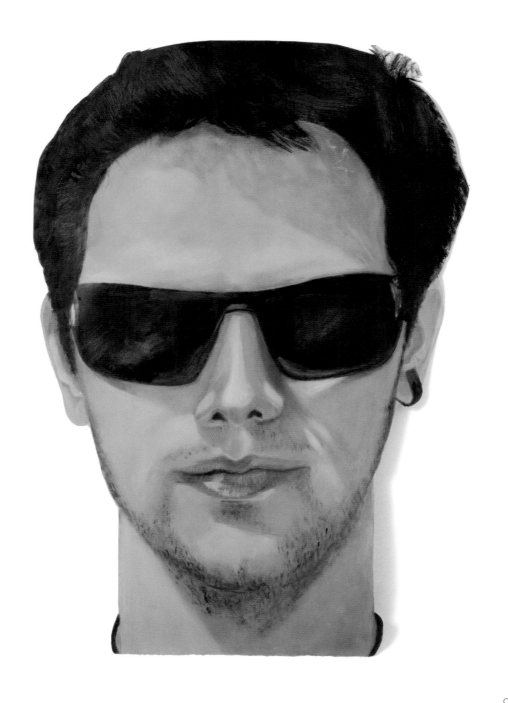

OPPOSITE: *William, 2008*
Oil on paper, cutout
23½ × 20 × 2 inches

Jack, 2011
Oil on paper, cutout
30 × 24 × 1½ inches

59

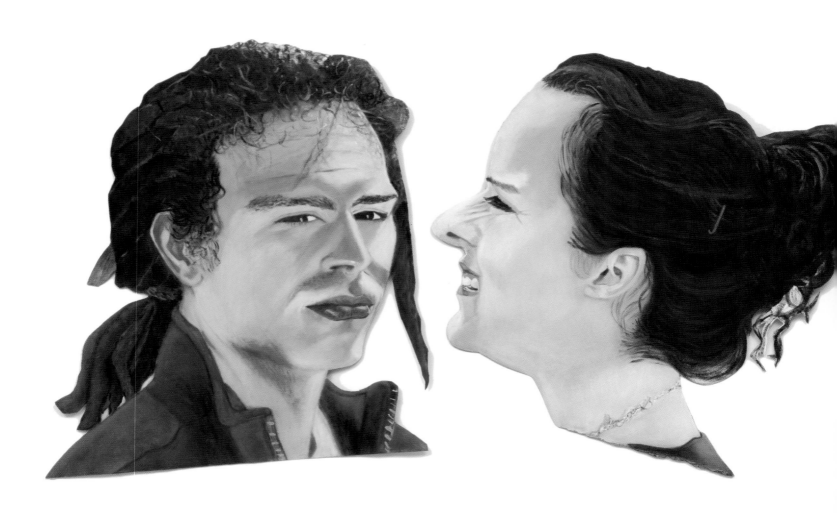

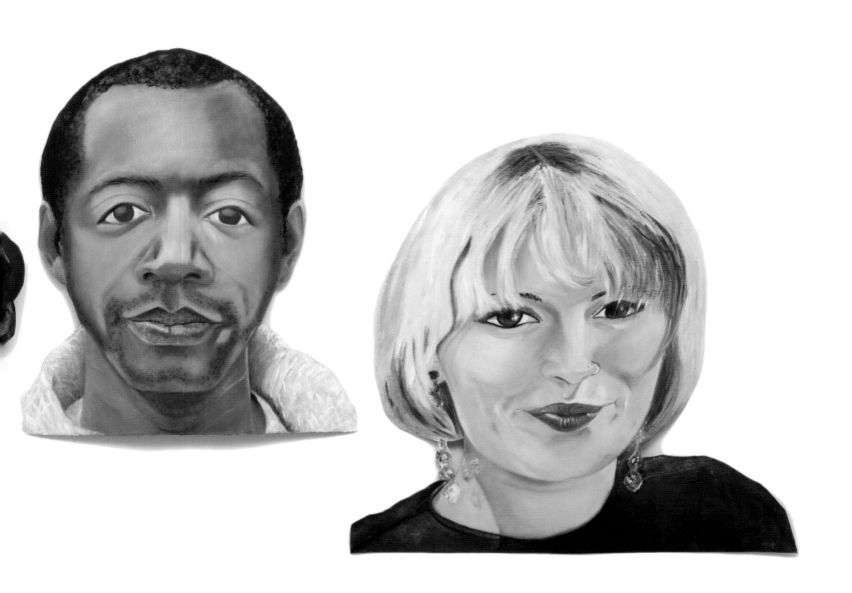

Young Americans (installation)

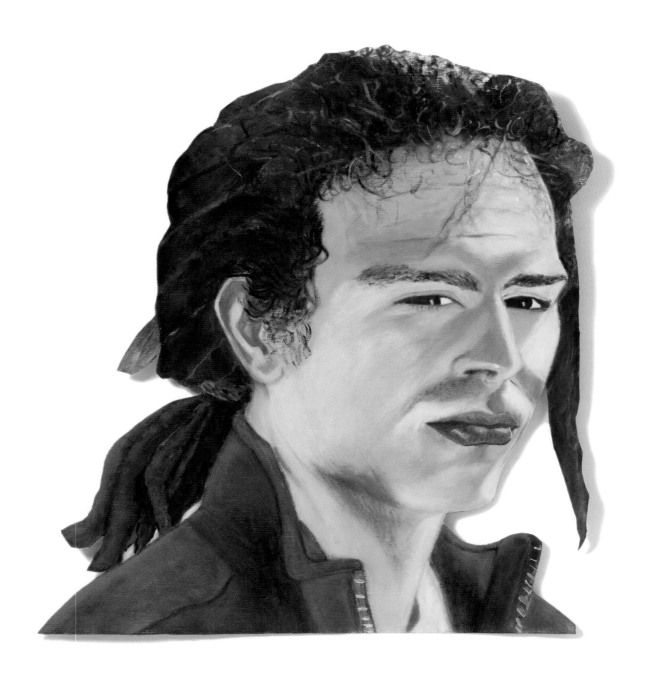

Adam I, 2010
Oil on paper, cutout
25 × 23 × 3½ inches

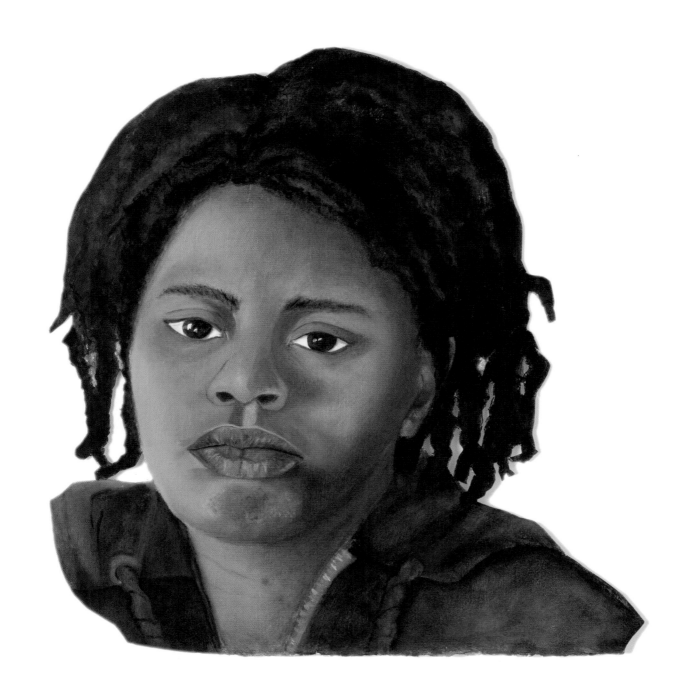

Areca I, 2005
Oil on paper, cutout
21 × 21 inches

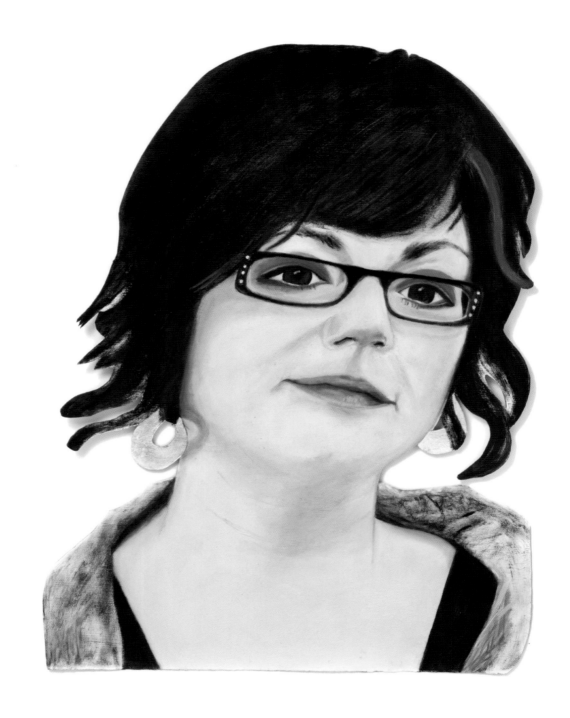

Mandy, 2010
Oil on paper, cutout
30 × 23 × 1½ inches

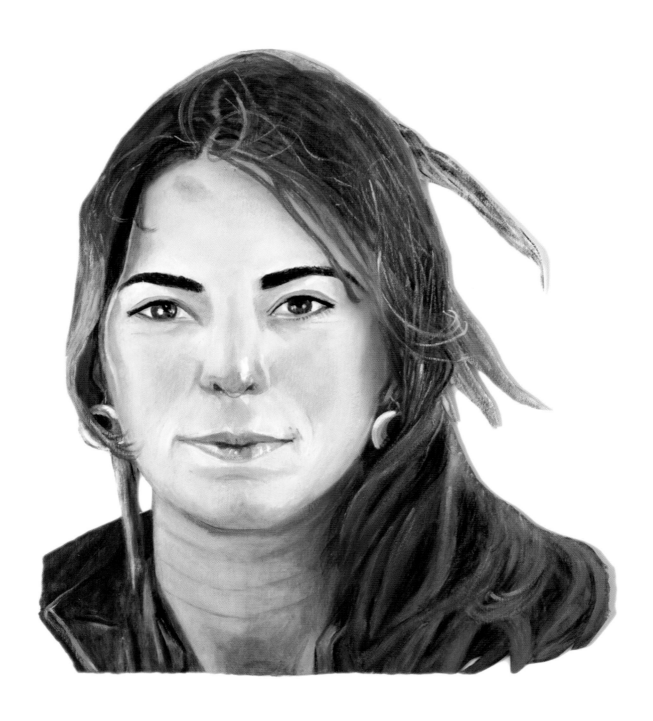

Paula I, 2006
Oil on paper, cutout
26½ × 21 × 2 inches

Geovanni, 2009
Oil on paper, cutout
24 × 22 inches

66

Christine, 2010–11
Oil on paper, cutout
28¼ × 22½ × 4 inches

Kara, triptych, 2011
Oil on paper, cutouts
Wall installation, 70×70 inches

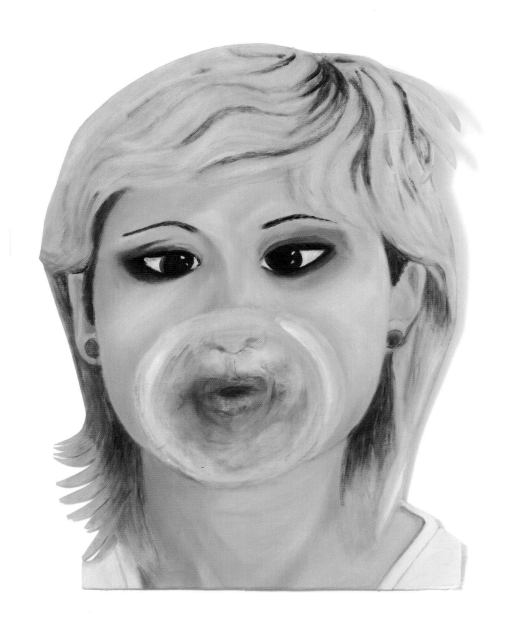

Kara, detail

COSMOPOLITAN IMAGINATION

Myth, History, Memory in Vesna Kittelson's Paintings

Joanna Inglot

Making art means… blending inside the crucible of the work both private and mythic images, personal signs tied to the individual's story and public signs tied to culture and history.

—Sandro Chia

Vesna Kittelson's paintings are visionary works. They have the power to arrest the viewers in a moment and carry them off to imaginary worlds. Her expressive canvases are explosions of fantasy and imagination, overflowing with multilayered narratives that speak of war, displacement, and entangled trajectories of the immigrant experience. Kittelson's paintings bring together diverse cultures, places, events, and personal experiences, which although temporally and spatially distinct are magically interconnected in a single "cosmopolitan universe." Working at the intersection of abstraction and figuration, her signature-style depictions of fragmented bodies and disjunctive pictorial narratives are filled with references to history, mythology, ancient heritage, and diverse periods of Western art. Rendered with unique fusion of painterly vigor and lyricism, they are vivid examples of expressive figuration on the contemporary art scene. Influenced by the New Image and the Neo-Expressionist revivals of representation and narrative possibilities in painting that had begun in the late 1970s and 1980s, previously banished or "exiled" by the formalist authority of Modernist abstraction, Kittelson's ultimate artistic aim is to explore the endless potential of painting as a medium and to affirm its relentless vitality and enduring importance in Western art.[1]

Born in Trebinje, Bosnia and Herzegovina, Vesna Kittelson was raised in the ancient city of Split, on the Adriatic coast of Croatia. She grew up in a region of spectacular natural beauty amid some of the best-preserved monuments of Roman architecture in the world, along with medieval churches and Renaissance and Baroque palaces.[2] The city's rich history and

continual layering of diverse cultures have been vital to her approach to art. As the artist recalled:

> *I was literally surrounded by fragments of Roman sculptures. Mosaics and frescoes were every-where, accessible to anybody. To me as a child, these fragments were electrifying and compel-ling riddles to solve. Later, I responded to them by becoming interested in painting body frag-ments, not the whole figure. A fragment of a body opened up an opportunity for the viewer to com-plete the image in his/her own way, which is more difficult with an already framed work.*[3]

Her insistence on such an imaginative and open-ended engagement with her art serves as an important springboard to the reception of all her creative endeavors.

Kittelson began her professional training as an artist after she immigrated to the United States and settled in Minneapolis in 1970. She received her BA in studio art in 1974 and an MFA in design from the University of Minnesota in 1978, with an emphasis on the study of color and abstraction. Her early paintings of 1977–80, such as *Design, French Interior (Rose and Green), Blue and Orange,* and *Nocturnus,* show her experimentation with Minimalism and Hard Edge Abstraction. The strong ethos of Abstract `Expressionism, still propagated at the University of Minnesota throughout the 1970s by pro-fessors George Morrison, Herman Somberg, David Feinberg, and others, led to Kittelson's fascination with monumental, gestural expression that came to fruition in her paper reliefs

Leap into America, 1999
Acrylic on canvas
56 × 50 inches

of 1982–89. Working with large sheets of paper directly on her studio's floor, she covered swaths of paper surfaces with acrylic paint, applying deeply saturated blues, purples, reds, and combinations of other hues with assertive and dynamic brushwork. She then used scissors to cut rectangles, spheres, and half-circles that could be folded and manipulated to investigate the physicality and mutability of form that could be shaped in a wide range of sculptural compositions.

Kittelson's *Kites* and *Gliders* of 1982 are early paper reliefs that explore the theme of flight, which has preoccupied her entire career. The forms in each individual work radiate strong inward and outward movement, creating shapes and patterns evocative of flapping wings and travel through space, culminating in the spectacular *Flight* (1984), which dramatically stretches across a surface as if to transgress all boundaries. Inspired in part by Elizabeth Murray's shaped canvases, the artist deliberately began to push her paper constructions from painterly abstraction to three-dimensional environments. She noted, "These constructed paintings are a dialogue between form and color, between the physical and spiritual. By cutting and shaping, I directly created a sculptural physicality in my paintings, which transforms them into an 'environment.'"[4] Some of the untitled paper sculptural reliefs from 1985–86 and works such as *Gate of Secrets* (1985) refer to fragments of walls, majestic gates, or imaginary cities. Kittelson's sensitive handling of paint and textures produces rich materiality of expressively layered surfaces that evoke cracked and burnished architectural fragments or old and damaged city fragments. Many of these works also register memories of her travels to Europe and her reflections on historic sites and ancient cultures she encountered there, which became an important foundation for her artistic expression.

A series of torsos from the late 1980s, including *Torso* (1988), *Torso with Wings* (1989), and *Londoners* (1988), announces a more sustained and complex engagement with figuration and the heritage of the ancient world by making specific references to fragmentary Greek and Roman classical statues of gods, warriors, and heroes. Many reference famous sculptures of female deities, including the masterpieces of Hellenistic art, such as the celebrated marble torsos of Aphrodite and the legendary *Nike of Samothrace*, with her outstretched wings, carried forward by blowing wind. These images not only pay tribute to the classical past but they stand as surrogates for the artist herself, dynamically leaping forward—an allegory of her immigrant experience and her desire to belong to a larger world and longer continuum of time. Kittelson's frequent quotations from classical art and ancient texts and her dramatizations of mythic stories became constant leitmotifs in her art and strong reflections of the Mediterranean spirit that underpins her work.

Vesna Kittelson's search for self-identity was fueled in large measure by her active participation in the feminist art collective WARM, the Women's Art Registry of Minnesota, where she was a member from 1979 to 1987. During this period, she gradually moved away from formalist preoccupations toward an exploration of subject matter and narrative content, often addressing topics that had significant personal meaning. In her paintings from the 1990s and in the series *Lost and Found in America* from the 2000s, she explores complexities of identity while opening up in her canvases new, imaginary worlds. In her groundbreaking autobiographical painting *Leap into America* (1999), Kittelson directs the viewer's attention to the legs of a standing female figure just about to dive into an abyss of unknown space. Following love and passion, the woman (symbolizing the artist) is taking a leap into the "New World," using old books and classical learning as a springboard for her departure.

Wings of Desire (1997) and *Gift of Wings (Advice)* (1998), among others, introduce an entirely new repertoire of art historical references that broaden the range of cultural belongings in Kittelson's art. In the first, Kittelson connects into one narrative, with meandering threads and ropes, culturally discrete images of the Egyptian queen Nefertiti with fragments of classical Greek female torsos and mythological cupids. In the second painting, a figure floating in the sky is trying to tie together a classical Greek portrait, a Byzantine basilica, a Roman amphitheater, and the icon of American pop culture, Mickey Mouse. In *Dreamtime* (1999), amid broken columns and classical ruins we find a portrait of the artist next to Frida Kahlo, while in *Tête-à-Tête with Tut* (1995) she emerges squeezed between the bust of Nefertiti and the golden mask of Tutankhamun.

Kittelson draws with great erudition on different artistic periods, making frequent references to ancient heritage,

Mediterranean culture, mythology, and contemporary life in America. She acknowledges the continuity and mutability of human experience and imagination. Collapsing together different motifs and traditions with frequent references to the Old Masters of Western art (Masaccio, Botticelli, Velázquez, and Goya), Kittelson is probing the boundaries between art and reality, while at the same time claiming nothing less than a "cosmic" territory. In her tableau *Cosmic House* (1999), for instance, she features a famous detail from Diego Velázquez's *Las Meninas,* showing the Spanish queen's chamberlain, José Nieto Velázquez, who opens a curtain of art history to a cosmic encounter with a contemporary couple passionately making love. She introduces an overtone of a theatrical spectacle in this tableau; such a convergence of staged drama and real life recalls strategies of Neo-Expressionist painters who came to international prominence in the 1980s, including Americans David Salle and Julian Schnabel, Anselm Kiefer in Germany, and the Italian Transavantgarde painters Sandro Chia and Francesco Clemente. All of these artists dramatize myth and art history as a "meta-language" and frequently use it as a backdrop to contemporary reality. Merging of the past and the present by Neo-Expressionists, as art historian James Cahill argues, helps to create a psychological immediacy between seemingly arcane subjects, everyday life, and the personal world of artists.[5] Like many of these artists, Kittelson individualizes art history and mythology to speak of her own time. By juxtaposing and fusing different realities, she constantly reminds us that we occupy a fluid and shifting plane. Residing "here" and "there," and in both places at the same time, we partake in an unfolding of a larger cosmopolitan world and cosmic universe.

Cosmic themes dominate Kittelson's paintings from the early 2000s. Her large-scale canvases such as *Cosmic Gardens* (2001–2), *Cosmic Sandals* (2002–5), *Kicking Stardust* (2002), and *Going Places* (2002), where figures move back and forth and in and out of the composition, constantly shifting directions and fields of vision, as well as smaller paintings such as *Cloud Catcher* (2002), in which fragments of hands play with and move around the clouds, all burst with an astonishing sense of energy and inner vitality but are also filled with lyricism and sensuality. Flooded with fields of intense reds, oranges, and glowing yellows, the feet, hands, and other body fragments in the compositions are animated by magically whirling brushwork. Moving across nondescript space, they have the power to lift the viewers to outer space, helping us fly exhilarated, higher and higher, to transcend all limits and boundaries, driven by the extraordinary power of cosmic forces and cosmopolitan imagination.

Notes

The epigraph is quoted in D. Waldman, *Italian Art Now: An American Perspective,* 1982 Exxon International Exhibition (New York, 1982), 11, and in A. Bonito Oliva, *The Italian Transavantgarde* (Milan, 1980), 18.

1. For discussion of painting's "exile" by Minimalist and Conceptual Art of the 1960s and 1970s and its return in the Neo-Expressionist movement of the 1980s, see Thomas McEvilley, *Exile's Return: Toward a Redefinition of Painting for the Post-Modern Era* (New York: Cambridge University Press, 1993).
2. Diocletian's Palace in Split (Spalato), built by the Roman Emperor Diocletian between 295 and 305 CE, is the largest and best-preserved example of Roman palatial architecture.
3. Vesna Kittelson, interview with the author, June 6, 2003.
4. Vesna Kittelson in *WARM: A Landmark Exhibition,* Hazel Belvo, ed., exhibition catalogue (Minneapolis: Women's Art Registry of Minnesota, 1984), 50.
5. James Cahill, *Francesco Clemente: Between Citation and Satire* (New York: CV Publications, 2013).

Wings of Desire, 1997
Oil on two canvas panels
60 × 123 inches

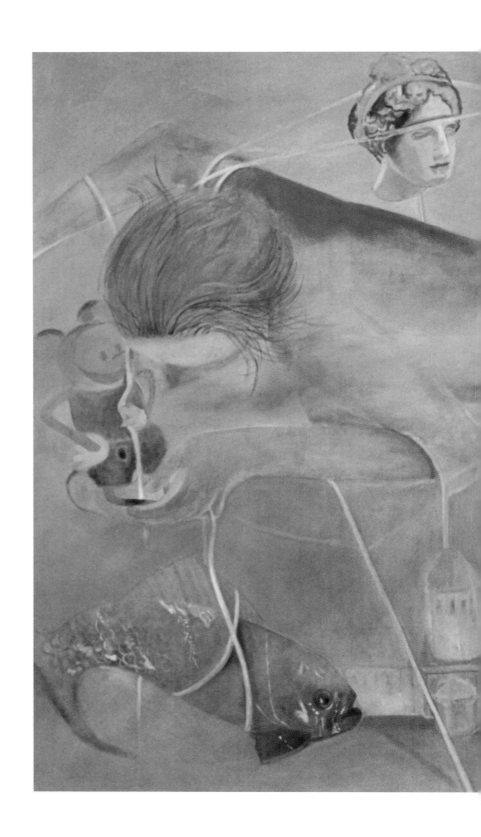

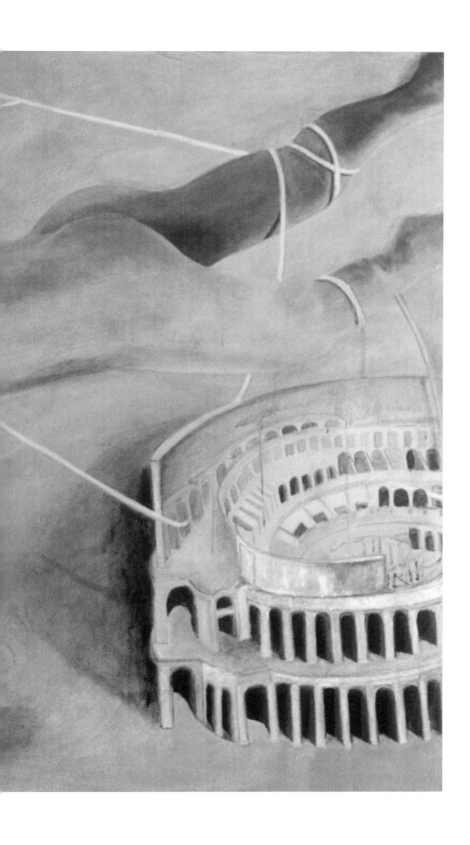

Gift of Wings (Advice), 1998
Acrylic on canvas
50 × 60 inches

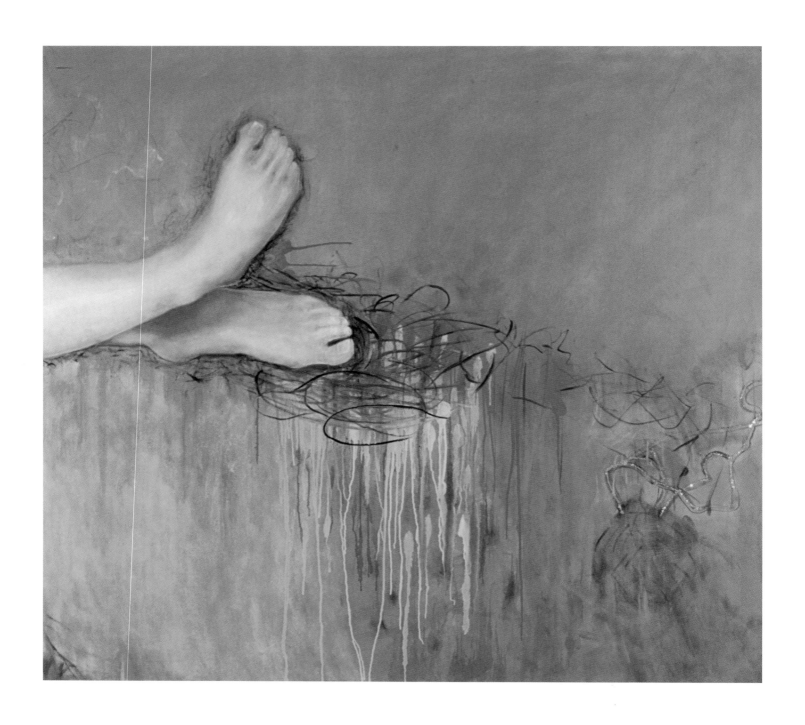

Cosmic Sandals (Phase One), 2002
Acrylic, oil, glitter on canvas
70×77 inches

Cosmic Sandals (Completed), 2005
Acrylic, oil, glitter on canvas
70 × 77 inches

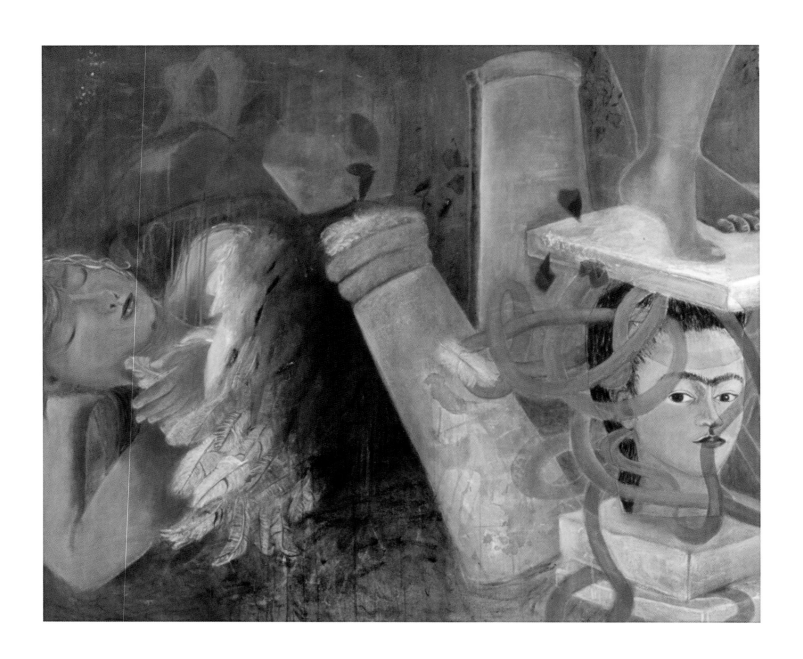

Dreamtime, 1999
Acrylic on canvas
50 × 60 inches

Cloud Catcher, 2002
Acrylic on canvas
30 × 38 inches

Walker Art Center, Library Rembrandt, self portrait
yes, Da Vinci, Augustus, Excavations, Ancient

Van Gogh

Library ... York ... Louise Bourgeois,
English Language, ...
color, stars, Dialects, Lives, ...
painting, Constitution, human rights
Kandinsky, Blue Rider, ...
Mississippi River, ... Green, Walker ...
Darwin, ... installation, ... Louise Bourgeois, ...
... Max Beckmann, hate, Earth
Marlene Dumas, Art, ...
Beauty, Poetry, energy, love, image, human
Kandinsky, ... Blue Rider
... Museum, poet
Greco, ... African masks, people
... Fresco, English words

(DE)CONSTRUCTING BOOKS

John Lyon

Vesna Kittelson has always been awed by the brilliance of books. Her lifelong fascination with book design and the gorgeousness of ancient illuminated books led to her making book art. She began her artistic career as a painter, and the book arts afforded her the opportunity to employ several mediums in a variety of techniques: she could combine painting, collage, drawing, sculpture, and text into one work. Several of her artist books have ultimately taken the form of a traditional book with pages and hard covers. They use accordion-style binding and can be read conventionally as a book or may be set up as a sculpture and fanned out. In her early works, Kittelson uses painting, collage, drawings, sculpture, and text. She makes traditional artist books but later her works take a more sculptural form when she alters language dictionaries. The dictionaries are treated with encaustic, gold leaf, tar, rust, iron, copper leaf, rubber bands, adhesive lettering, and paint to make them indistinguishable from one another, forming a common language among many books of several languages. Even though Kittelson makes two very different styles of artist books, they still express the common themes of democracy, community, relationships, experience, immigration, and love. Her love of book art and her reimagining of books into other forms have transformed her artistic oeuvre, opening her art to new techniques and new audiences.

Kittelson evolved into a book artist because of Charles Darwin. She was living in Cambridge, England, in 2009, during the 200th anniversary of his birth and the 150th anniversary of his published theory of evolution, *On the Origin of Species*. Kittelson not only wanted to mark these anniversaries with new work but she was also eager to explore the relationship of Charles Darwin and his wife, Emma Wedgwood Darwin. Kittelson stated: "I became consumed by the unexpected realization that his life with wife Emma Wedgwood was one of great love, risk, sacrifice, and triumph. How to celebrate their exceptional love story, overshadowed by the impact of the theory of evolution, through art, became a central question in my work." The answer to this question moved Kittelson into the book arts she is known for today. Rather than painting on a canvas, as much of her art until this point had been, she decided that making an artist book would best express the love story of Emma and Charles. As she told me with a laugh, "Charles Darwin was a real lover boy"—a picture that usually doesn't come to mind when thinking of Darwin. She was interested in the relationship between Charles and Emma as well as the role of religion and science in it. Charles is believed to have delayed his publication of *On the Origin of Species* for twenty years because of Emma's strong religious faith. Kittelson decided to make an accordion-fold book that could be freestanding, as though the pages were a display in a natural history museum.

Bright colorful collaged flowers and text make up the four volumes of *Mrs. Darwin's Garden* (2014–15). Each book is accordion-style binding, allowing the books to stand up and be viewed like flowers. The flowers are drawings with ink and color pencils and poured paint on paper, which is then cut into flowers. The flowers are imaginings of what Charles Darwin might have seen during his travels and explorations on the *Beagle* and how they might have been used to create a garden for Emma. *Mrs. Darwin's Garden*, books 1–3, were shown at Form + Content Gallery in Minneapolis in 2014. The

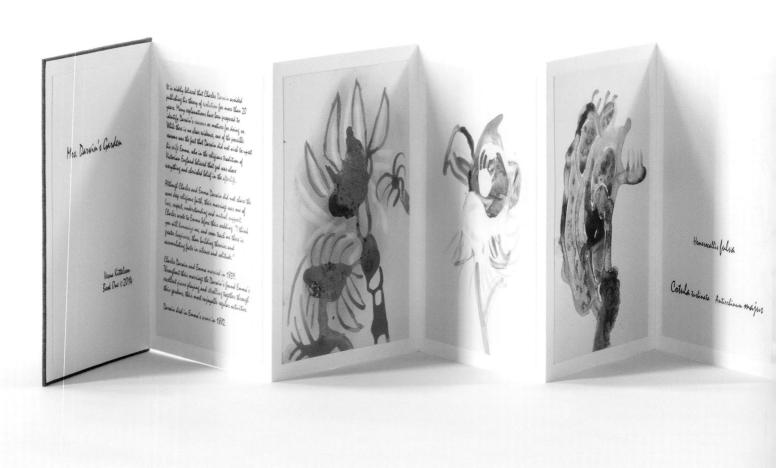

Mrs. Darwin's Garden

Verne Kittelson
Book One © 2014

It is widely believed that Charles Darwin avoided publishing his theory of evolution for more than 20 years. Many explanations have been proposed to identify Darwin's reasons or motives for doing so. While there is no clear evidence, one of the possible reasons was the fact that Darwin did not wish to upset his wife Emma, who in the religious tradition of Victorian England believed that god was above everything and cherished belief in the afterlife.

Although Charles and Emma Darwin did not share the same deep religious faith, their marriage was one of love, respect, understanding and mutual support. Charles wrote to Emma before their wedding: "I think you will humanize me, and soon teach me there is greater happiness, than building theories and accumulating facts in silence and solitude."

Charles Darwin and Emma married in 1839. Throughout their marriage the Darwin's found Emma's excellent piano playing and strolling together through this garden, their most enjoyable regular activities.

Darwin died in Emma's arms in 1882.

Hemerocallis fulva

Cotula turbinata Antirrhinum majus

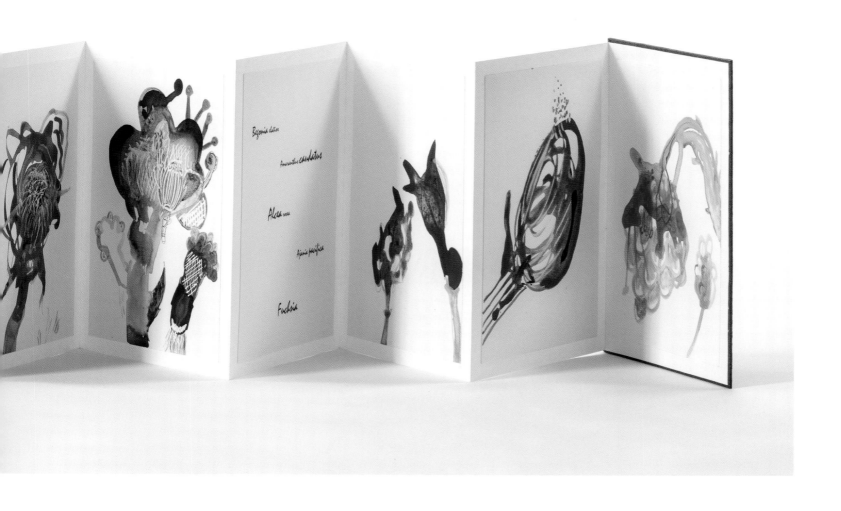

Within the image, the following text appears on the book pages:

Begonia *elatior*

Amaranthus *caudatus*

Alcea rosea

Azonia *pacifica*

Fuchsia

Mrs. Darwin's Garden, Book One, 2014
Water-based paint on paper
9 × 7 × ½ inches
Edition of 6

Mrs. Darwin's Garden, Book One, detail

four books were also featured in *Dear Darwin,* an exhibition at the Weisman Art Museum in 2017 that explored themes of natural science, evolution, and Charles Darwin.

Fountains (2016) was the follow-up to *Mrs. Darwin's Garden,* because, as Kittelson said, "every garden needs a fountain." She recalled her youth in Split, Croatia, where she passed a fountain twice every day, on her way to and from school. The illustrations are drawn from the memory of actual fountains, including Gradska Fontana in Split; the Trafalgar Square fountains in London, England; and Fontana di Trevi in Rome, Italy. Just as *Mrs. Darwin's Garden* explored the loving relationship between Emma and Charles, *Fountains* has other themes important to Kittelson: democracy and community, which appear frequently in her work. This book invokes the meeting places and sense of community in many European cities—all classes of people coming together, rich and poor, young and old, to enjoy, interact, and mingle. *Fountains* incorporates paintings, drawings, and collage in metallic silver and gold paint. The illuminated colors give the images a late afternoon glow and sparkle. *Fountains* is an accordion-style artist book of two volumes.

Kittelson's inspiration for her next artist book was much more contemporary. While reading the *New York Times* and Minneapolis–St. Paul *Star Tribune,* she noticed several articles about drones, which sparked her interest in the boundaries between art, science, myth, and experience. She started thinking about early desires of flight and how it was represented in arts and myths and how those desires and myths correlate to today's pilotless aircraft. This interest led to her accordion-style artist book *Da Vinci and the Drone* (2016). She engages the myths of Icarus, Eros, and Nike and the contemporary fictional characters Superman and Tinker Bell to express the human desire to fly. She also refers to Yves Klein and his imagery of flight. Leonardo da Vinci caught her attention with his thirty-year obsession with flight and his use of science, observation, and imagination. Essays by Lois Eliason and Susan Thurston are also included in *Da Vinci and the Drone:* Eliason writes about da Vinci and his work with flight, such as *Codex on the Flight of Birds,* and Thurston's essay concerns the uses and ethics of drones.

Artist's Babel Font (2018) is much like Kittelson's early work in style and production. Using altered dictionaries to create a unifying language of books, *Artist's Babel Font* uses new text characters to make a new language. The characters are similar to current English letters. Familiar letters have new appendages to make new words—words that won't lead to chaos or misunderstandings. With these new letters, the similarities between peoples will be highlighted, not the differences, enabling communication across cultures. Kittelson explores the role of language in human conflict and the effect of conflict on language: a common language inspires hope for less conflict. As Kittelson notes in the book's foreword, "as an immigrant, and as an artist, I have held a long-term fascination with boundaries and thresholds based on words." The new letters are collaged and drawn much like her work in *Mrs. Darwin's Garden* and *Da Vinci and the Drone.*

Kittelson began to explore similar themes through altered books, repurposed multi-language dictionaries. By applying encaustic, iron, copper leaf, tar, rubber bands, and adhesive letters, she makes the foreign language dictionaries indistinguishable from each other, yet again creating a common language. She cuts the dictionaries to make them unique in shape and size; sometimes she forms them into shapes of letters. She incorporates the altered dictionaries into the sculptures *Babel Tower I* (2013), *Babel Tower II* (2013), and *Babel Library–Peace Library* (ongoing), made of used dictionaries, wood, and fabricated metal. In *Babel Tower I,* she combines foreign language dictionaries covered in encaustic and a classical pillar 9 feet high and 8 inches in diameter; the tower is purposely off-center and tilting. In *Babel Tower II,* the altered dictionaries are placed on a plinth. When altered, the dictionaries present unexpected and unknown visual qualities—they appear both familiar and surprising. Advancing from the idea of *Babel Towers,* Kittelson places altered dictionaries in a sculptural library: *Babel Library–Peace Library* might be the library you would have found in the Tower of Babel. More than 450 altered dictionaries on two fabricated metal bookshelves on coasters can be moved around, picked up, and examined, bringing groups of people together. "In my art," Kittelson says, "I find that sculpture/installation is the most appropriate medium for addressing chaos, violence, and instability caused by misunderstandings among different human groups and nations in today's world." Kittelson has a lot to say in her altered books, but it is not said with words. She gives the viewer a road map to understanding cultural differences and learning how to transform those differences into a unifying bond.

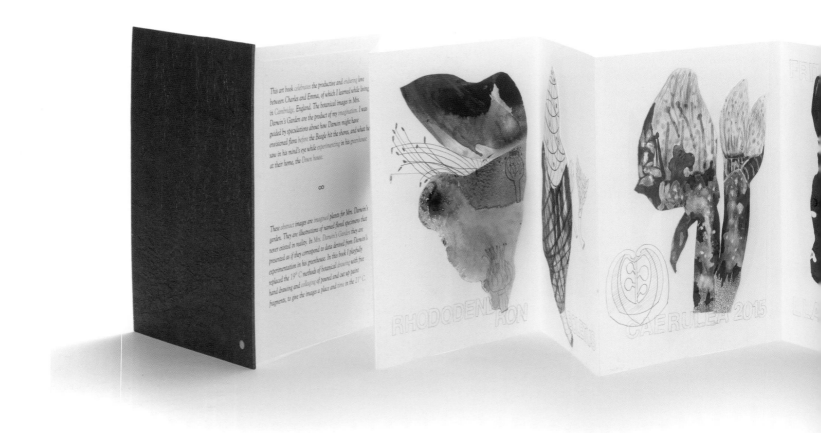

This art book *celebrates the productive and enduring love* between Charles and Emma, of which I learned while living in *Cambridge, England.* The botanical images in Mrs. Darwin's Garden are the product of my *imagination.* I was guided by speculations about how Darwin might have envisioned flora *before* the Beagle hit the shores, and what he saw in his mind's eye while *experimenting in his greenhouse* at their home, the *Down house.*

∞

These abstract images are *imagined plants for Mrs. Darwin's* garden. They are illustrations of named floral specimens that never existed in reality. In *Mrs. Darwin's Garden* they are presented as if they correspond to data derived from *Darwin's* experimentation in his greenhouse. In this book I playfully replaced the 19° C methods of botanical *drawing with free* hand drawing and collaging of poured and cut up paint fragments, to give the images a place and time in the 21° C.

Mrs. Darwin's Garden, Book Four, 2015
Water-based paint on paper, collage
9 × 7 × 1 inches
Edition of 10

Darwin delayed publishing
20 years. Many
While there is no clear
been that Darwin did
ho followed the religious
ieving that God's power
a belief in the *afterlife*.

in did not share the
iage was one of love,
support. Before their
'I think you will
ere is greater *happiness*,
ating facts in silence and
na *married* in 1839.

wins found their most
ma's excellent *piano*
h their gardens.

82.

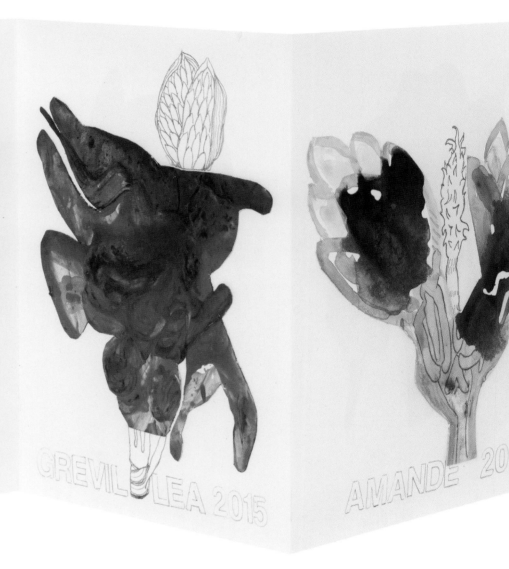

GREVILLEA 2015

AMANDE 2015

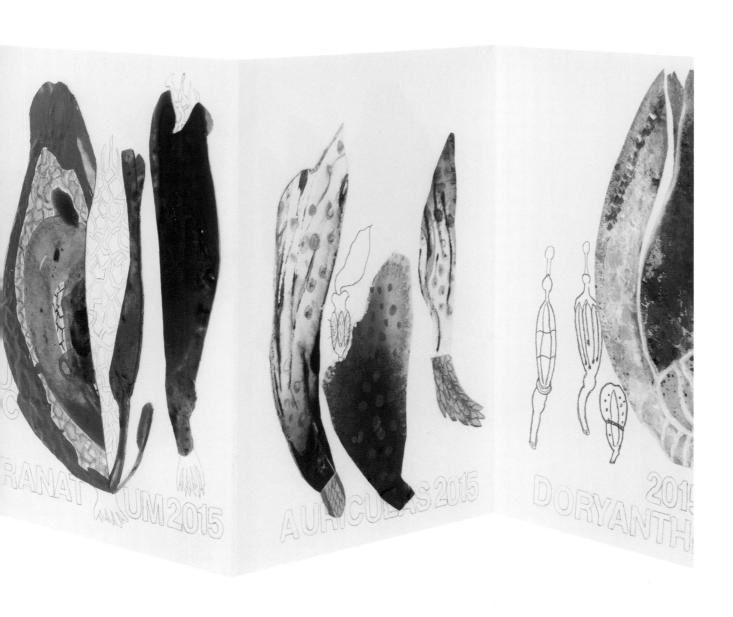

Mrs. Darwin's Garden, Book Four, detail

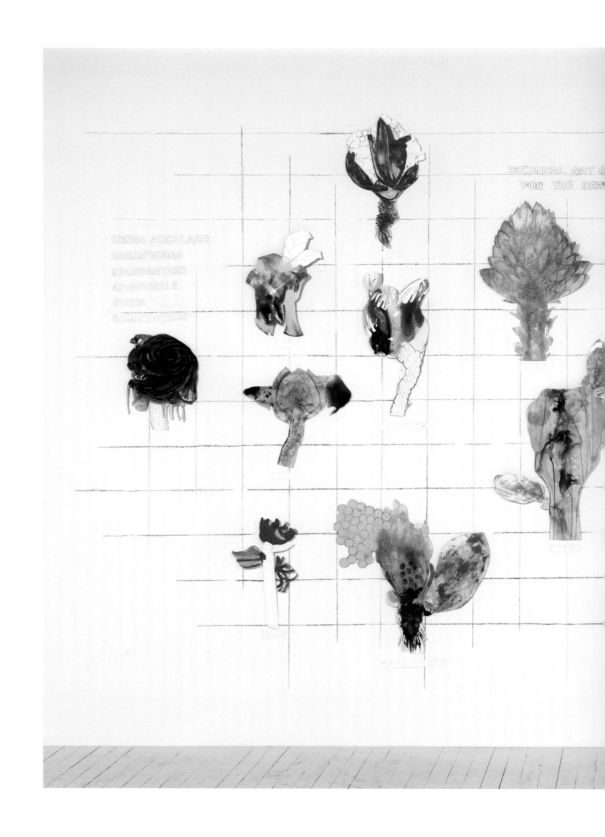

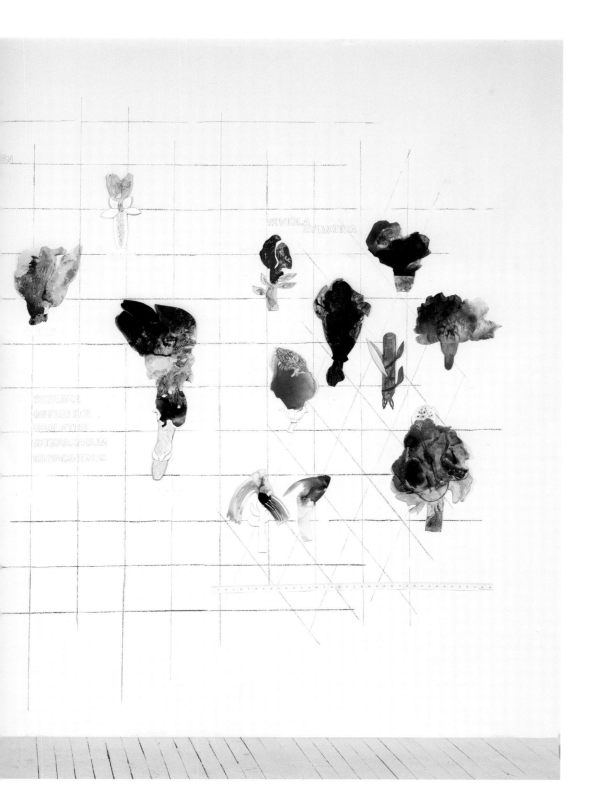

Botanical Art Garden for the Darwins, 2017
Wall installation – specimens, water-based paints on paper,
cutouts, charcoal grid on wall, labels
96 × 130 inches

NEXT PAGES:
Botanical Art Garden for the Darwins, details

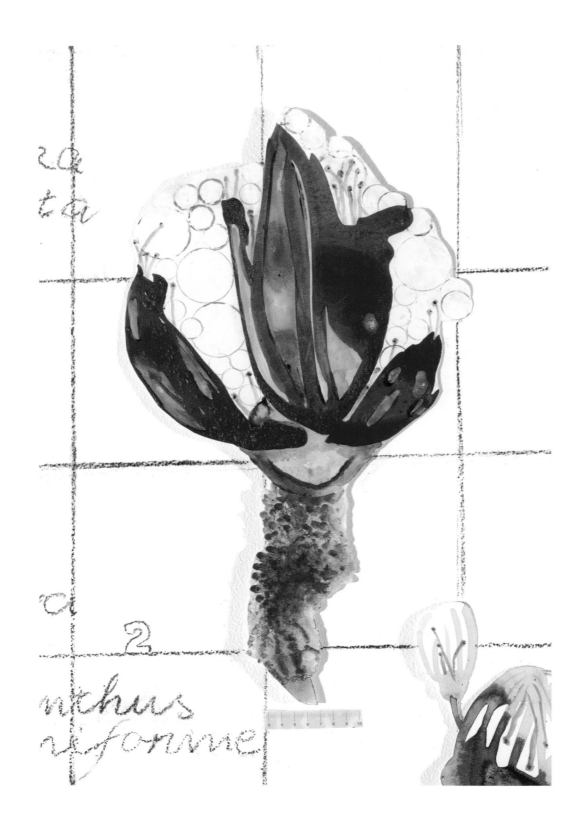

Da Vinci and the Drone, 2016
Mixed medium on paper
11 × 9 × 1 inches
Edition of 10

Da Vinci and the Drone, detail, palimpsest

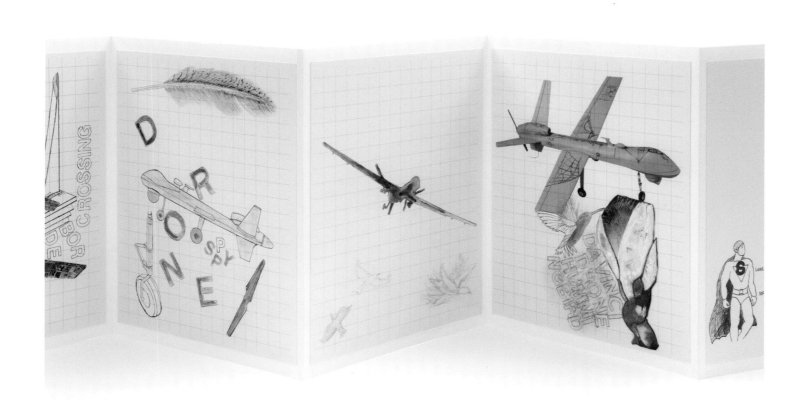

Da Vinci and the Drone, detail

Da Vinci and the Drone, detail

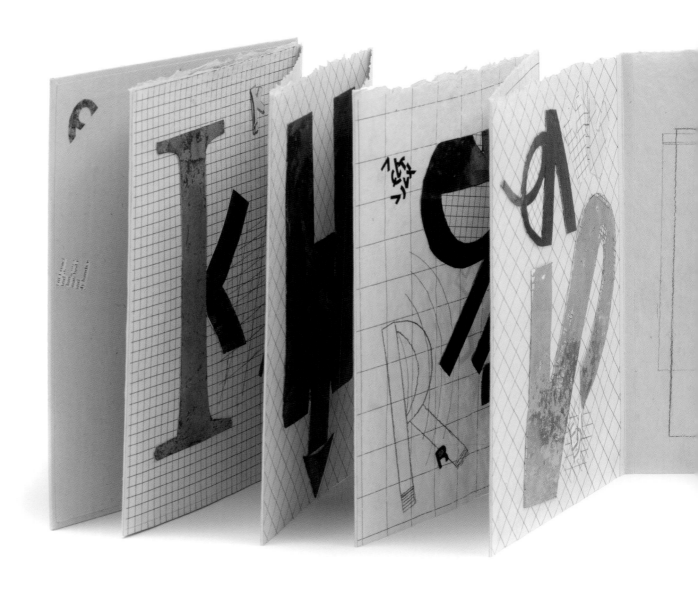

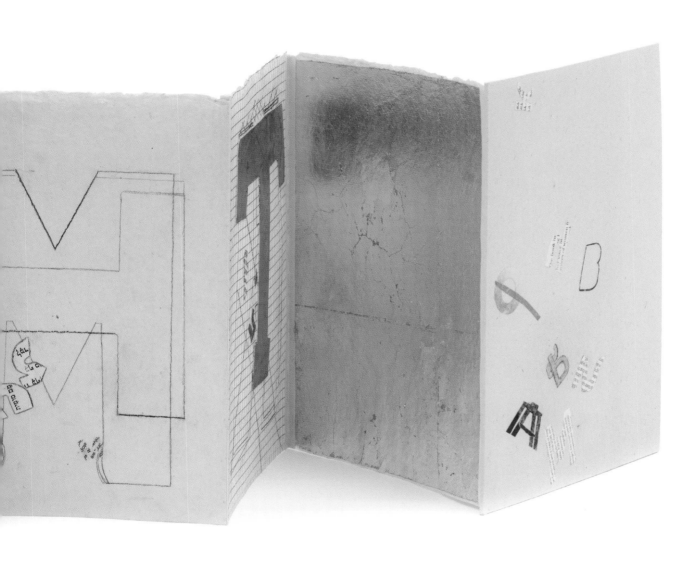

Artist's Babel Font, 2018
Mixed medium, collage
Unique, 10 ⅞ × 8 ⅝ × ¾ inches

NEXT PAGES:
Artist's Babel Font, page-letter H
Artist's Babel Font, page-letter V

103

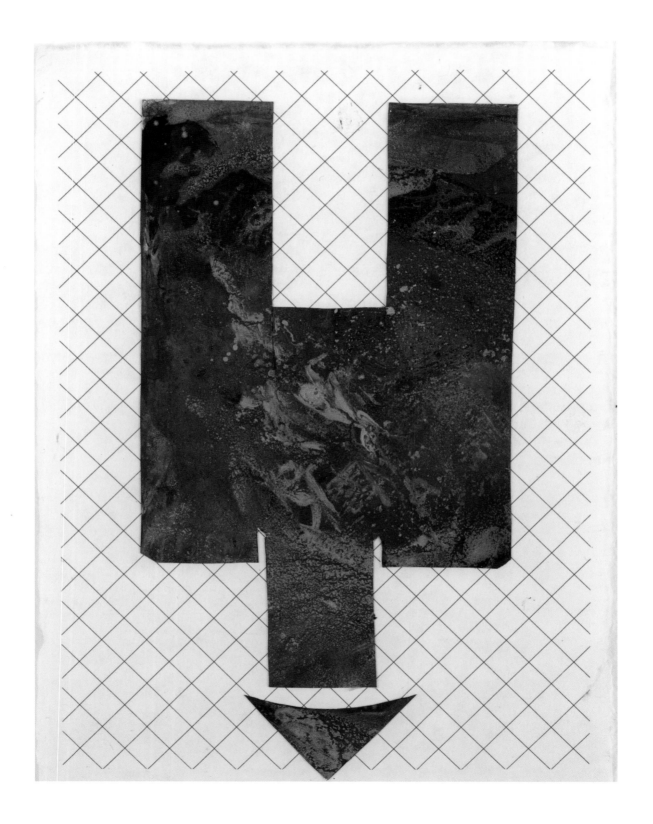

104

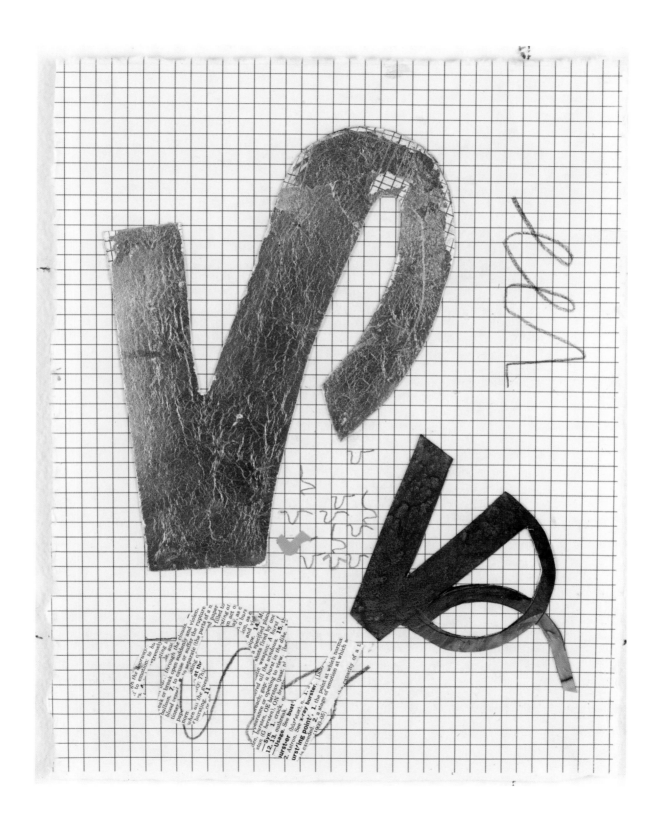

FOUNTAINS

Of Glitter and Glints

Kerry A. Morgan

These drawings, in silver and gold, are fragments of childhood memories. They are recollections of the color of water falling, shining silver in the morning light and glowing gold in the afternoon sun. They reference a lived experience: the artist passing by a fountain twice each day as she walked to and from school through a public park in her hometown of Split, Croatia.

The particularities of place dissolve here into perceptual sensations. These minimal, gestural drawings capture a unique relationship of water and light, the phenomenon of glitter and glints. Particles in water absorb, scatter, and reflect light. Still water might look lifeless, but in motion the vibrating field of light on water sparkles, an effect called "glitter," which is comprised of countless "glints" that appear and disappear faster than the human eye can follow.

This mesmerizing effect is rendered in this series of drawings in endless variations. Dense walls of silver tumble heavy and spray mist effervescent. Attenuated silver ribbons descend— flowing, pooling, swirling. Gold daubs billow full. Strands of gold cascade feverishly, not bound by the thin graphite frame that counterbalances the spontaneity of brushwork in each drawing. They are all light and water, devoid of architectural references save a crescent-moon gesture filled with gravity's weight. Stunning meditations on the passage of time, their visual effects are always in flux as the viewing light conditions change. Seemingly ceaseless, increasingly valuable—water rendered the most precious of elements.

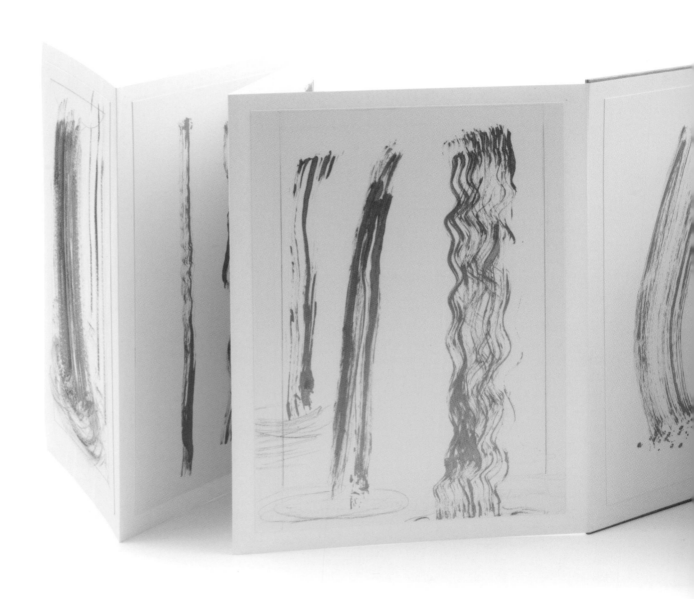

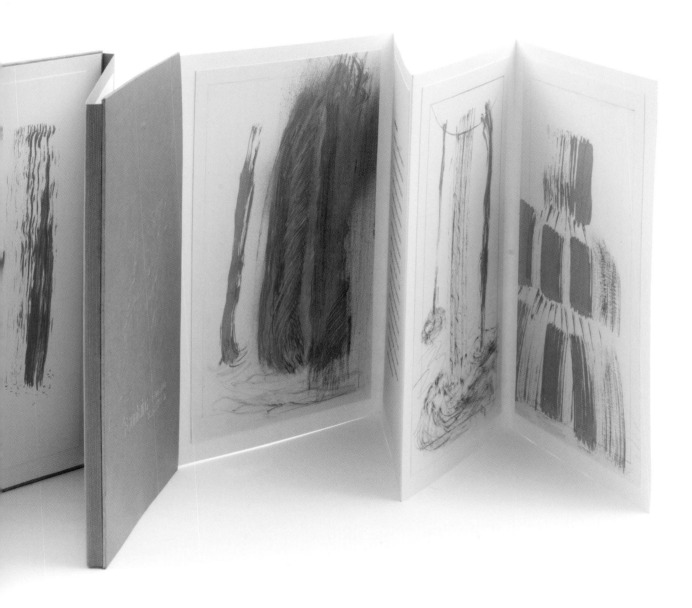

Fountains, volume two, 2016
Metallic paint, dos-à-dos binding
Unique, 11⅛ × 8¼ × ¾ inches

This mesmerizing effect is rendered in this series of drawings in endless variations. Dense walls of silver tumble heavy and spray mist effervescent. Attenuated silver ribbons descend - flowing, pooling, swirling. Gold daubs billow full. Strands of gold cascade feverishly, not bound by the thin graphite frame that counterbalances the spontaneity of brushwork in each drawing. They are all light and water, devoid of architectural references save a crescent-moon gesture filled with gravity's weight. Stunning meditations on the passage of time, their visual effects are always in flux as the viewing light conditions change. Seemingly ceaseless, increasingly valuable - water rendered the most precious of elements.

Kerry A. Morgan

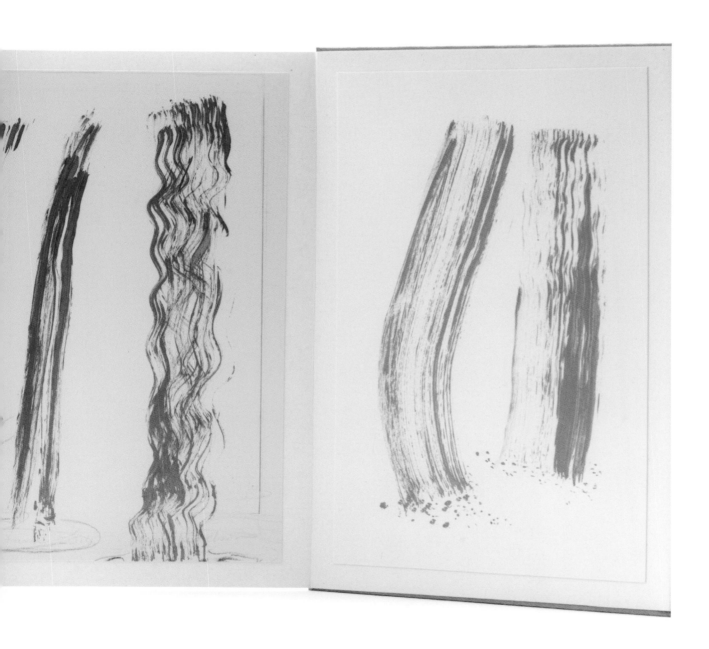

Fountains, volume two, detail

111

ALPHABET OF RUINS

Marcia Reed

Now barely recognizable as letterforms, Vesna Kittelson's signature alphabets made from ruined books turn stylish shapes into questionable characters. Shaggy works on paper are migrants from their former meaningful lives as foreign language dictionaries. As reference books, dictionaries used to have a prominent place in libraries and offices. They could be found on desks or nearby shelves, alongside the two-volume *Oxford English Dictionary* (with its accompanying magnifying glass), a thesaurus, and *Fowler's Dictionary of Modern English Usage*. Pocket versions augmented with useful phrases were made to be packed in suitcases for travel abroad. Now orphaned, they are refugees. Such handy reference books are no longer needed since cell phones, laptops, and the internet supplant desks and offices. Libraries are downsized, bookshelves are replaced by countertops, monitors, and plentiful connections for recharging with plug-ins. Thanks to Twitter, no one writes complete sentences anymore, not to mention the unfamiliar idea of drafting formal letters on paper to be sent through the mail.

With reference to words, definitions are simplified. Language is discussed mainly in terms of whether it is foreign or not because all immigrants must learn English. Perforce, dictionaries have become senior citizens in the steadily shrinking world of reference books. Prime candidates for the trash bin or shredder, soon they will be extinct. Still bursting with words and the inscrutable knowledge of their former uses, Kittelson's compact tomes already bear marks of encounters with sharp instruments such as knives and saws. Now serving as substance for sculpture, whittled down to a single letter, the books have morphed into small monuments or memorials.

Although replete with words, in essence, each volume has been reduced to a character. Neither intact nor readable, they hold no hints of their former employment or residences. No epitaphs, no place, no dates. Intentionally rendered incomplete, the volumes are now fragments. Reminding us of what they used to be, and their past attentions from readers, they make us consider the present role of books. While we read and receive meaning now from screens, in contemporary culture the book retains its status as a conceptual space. Still seen as a container of meaning, its materiality purveys a purposeful role as a work on paper: texts on pages written or composed by and for someone.

Kittelson has either found these distressed volumes or rendered them a shambles. Their present state of disarray is disturbing. Books as refuse seem a desecration. Something is not right, especially if this is intentional destruction. Death to the book! Yet even in this condition as a state of afterlife, books have a strange beauty, as wrecks and ruins often do. Poignant or worse, wrenching, they turn sentimental, valuing what we have lost. From another perspective, Kittelson is not a book-wrecker but a kind of biblio-savior who has rescued and salvaged the dictionaries, creating their new incarnations as artist's books.

At first glance, the books are indistinct and illegible shapes, waiting and hoping to be recognized. Having lost their covers, they are like old friends whose names we cannot quite remember. They are an engaging puzzle to be solved. What are these throwaways and cast-offs? They are not rare books, just humble trade editions, old-school everyday handbooks.

113

Perhaps that makes them more wistful or sad as reminders of a former life when they were needed. Their letterform shapes refer back to the elements of a dictionary: alphabetically organized words in books. Now they are sculpted as if they were official, blocklike buildings in the Cold War, brutalist architectural styles. Like graffiti painted on dilapidated buildings, the text-blocks are redecorated, resembling old ladies with their hair done, made up and decked out in their Sunday best accessories and jewelry, with bright lipstick and rouge. Seemingly haphazard cosmetic treatments, embellishments of gold leaf, printed ephemera, with covers made of postage stamps (also facing extinction in the current world of online communications), provide a surprising punk beauty to each tome. Occasionally, the books are in need of a bit of support (like a senior's cane or walker): they lean and list uncertainly on their page edges when stood up for display.

Artists have long been engaged with the design and shaping of letters, mostly in two dimensions, occasionally in bas-reliefs such as Roman capitals. Among the earliest printed books, two illustrated works feature classic designs for alphabets: Luca Pacioli's *Divina Proportione* (Venice, 1509) and Albrecht Dürer's *Unterweysung der Messung* (Nuremberg, 1525). In these stunning books, both page compositions and letterforms express the harmonies of size and shape. In particular, the latter treatise integrates human proportions with those seen in alphabets. The assumption is that design and proportion present immutable truths about beauty. These are best explicated in texts and images that illustrate their exemplary meanings. The perfection of mundane design and form mirrors the eternal divine wisdom that the artist and author transmits.

Did you think that letters are as simple as A B C? The alphabet is a deep structure of complex signs. Embedded in specific cultures, like all systems of writing, each alphabet has its own complications of language and style. Indeed, what is expressed by a single letter when it is nearly abstract, made out of a book that has been mutilated? Kittelson's books are particularly complicated because this is not respectful handling—it is exactly what should not happen to a book. On first glance, the artist's approach is akin to burning or tearing a text apart. No longer a text, and not really legible, but on close examination one sees that each of Kittelson's books retains its structure and its elements. Just barely recognizable, it is a purposeful ruin, an Expressionist or Dada version of a book. It is strangely appealing, similar to Piranesi's nostalgic etchings of ancient architectural ruins; they somehow sentimentalize the damage by depicting ruins with overdecorated surfaces of cracks and crannies. Kittelson treats her tomes in a similar way, creating not with acid but by means of shop tools. The volumes are sawed and hacked into shape (or out of shape, if you're remembering them as books). They are painted and collaged with found papers and postage stamps, Kurt Schwitters–style, not only salvaging the books but also repurposing accessory throwaway papers.

Now shaped as single letters, the dictionaries tend to look lonesome and desolate, perhaps searching for new contexts in which to make meaning. Ruined in both their physicality and concept, they are fragments without framing context, mimicking an urban landscape of decaying structures, purposely destroyed, perhaps, or simply abandoned to the elements. We speculate about who lived here: what did they do? We scrutinize these objects formerly known as books and wonder: what happened? What is going on? However bulky and misshapen they are when seen singly, the books benefit from assembly as a group. As a substantive mass, they seem to gather and address themselves to the primary task of communication, which is always a group project, like reading. Dictionaries point out that language is communal and cultural, sharing agreed-upon meanings. Where are we now? What happens when dictionaries are no longer needed or valued and are thrown away? Can we see Pacioli and Dürer at one end of the continuum of the history of books and Kittelson's book-sculptures on the other? Are they THE END?

OPPOSITE:
Babel Column, 2013–14
Wood classical column, altered language dictionaries,
encaustic, adhesive letters, lead
108 × 16 × 16 inches, column 8 inches in diameter

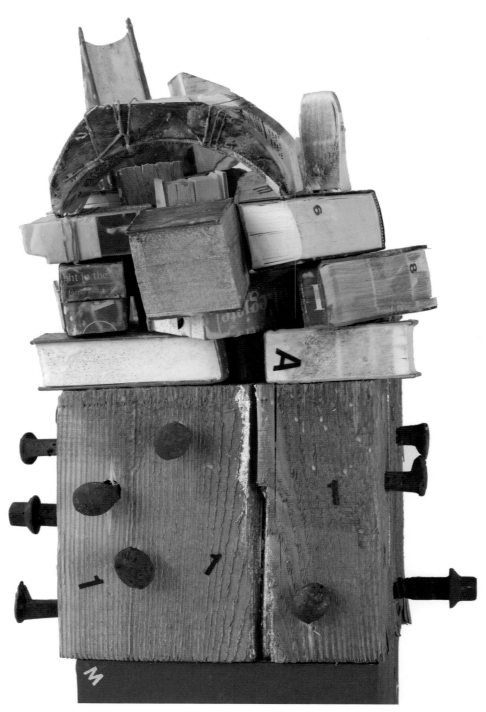

Babel Tower II, 2013
Mix of salvaged language dictionaries,
wood plinth, adhesive letters, copper, metallic leaf
72 × 11½ × 11½ inches

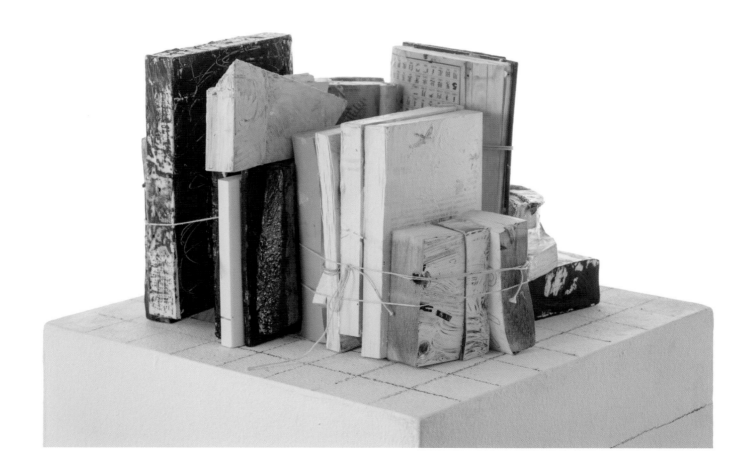

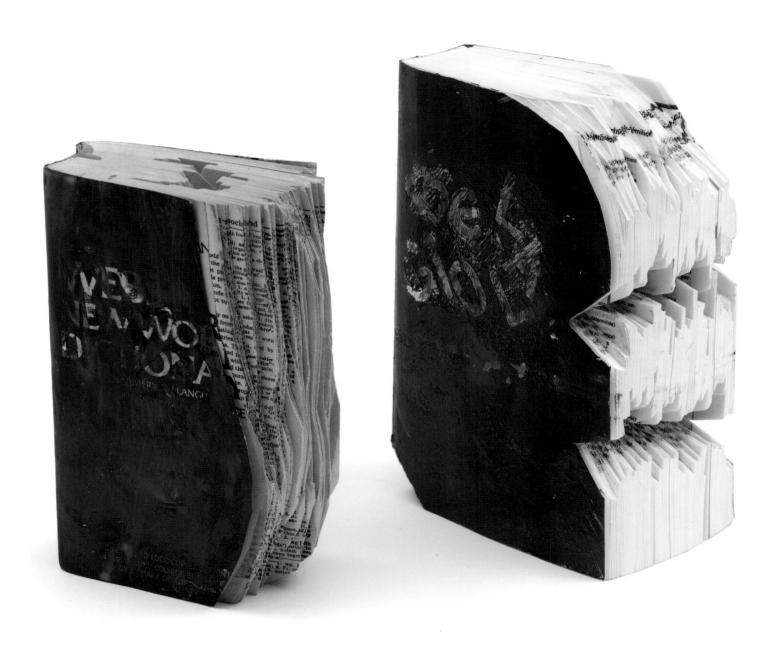

PREVIOUS PAGE:
Language Mix, 2016
Altered salvaged language dictionaries,
wood plinth, tar, strings, encaustic
67 × 13½ × 13½ inches

Two Black Language Dictionaries, 2017
Salvaged language dictionaries, powdered charcoal
7 × 4⅕ × 1½ inches
8 × 5 × 1½ inches

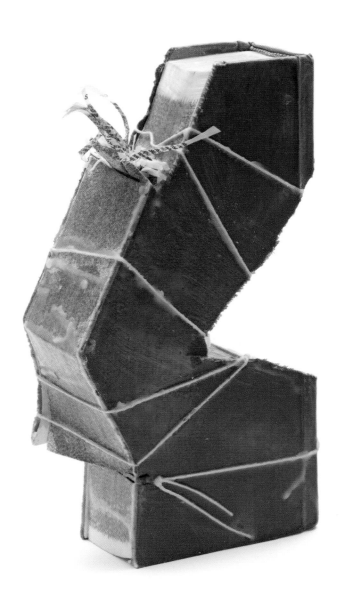
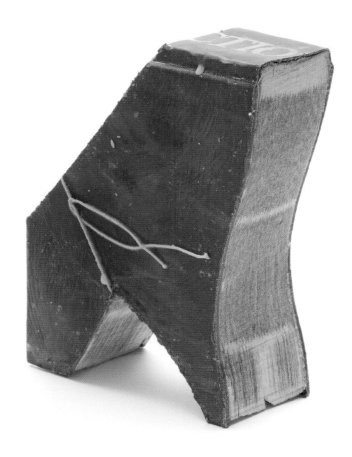

Broken and Mended I, 2017
Salvaged language dictionaries, encaustic, strings
9 × 7 × 2 inches; 7 × 5½ × 2 inches

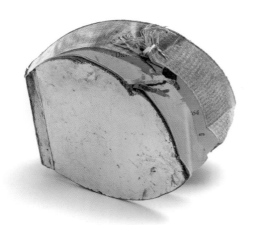 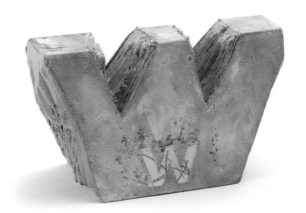 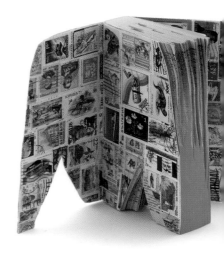

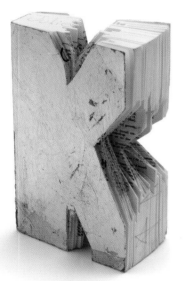
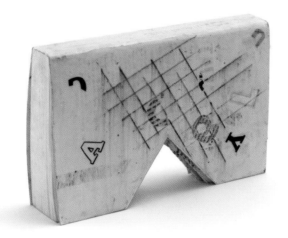
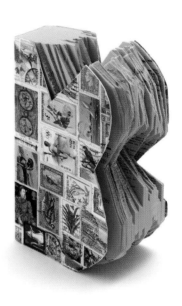

Six Altered Language Dictionaries for the Getty, 2018
Salvaged language dictionaries, mixed medium:
acrylic paint, metallic leaf, encaustic, cancelled stamps
Installation surface 40 × 60 inches

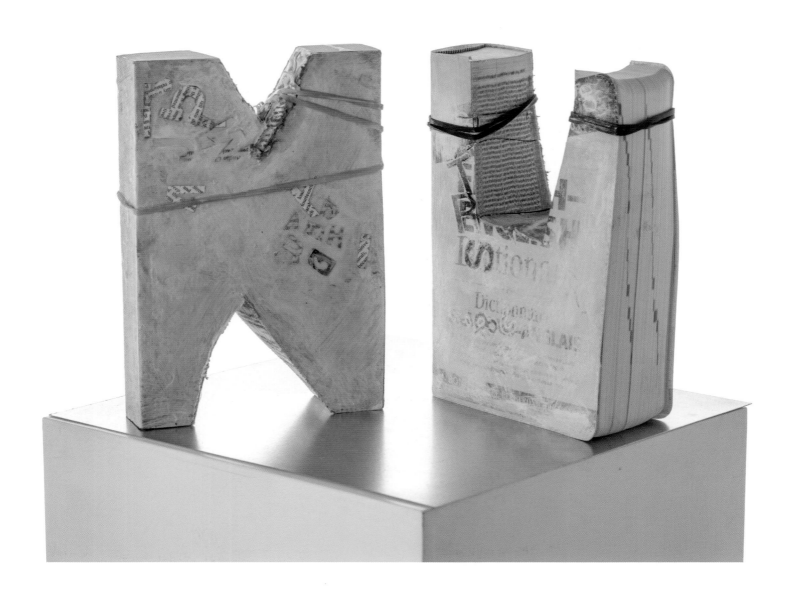

Similar, 2018
Salvaged language dictionaries, acrylic paint, encaustic,
adhesive letters, rubber bands, wood plinth, stainless steel plate
U shaped book: 8¾ × 6⅛ × 2¼ inches
N shaped book: 9 × 6 × 1½ inches

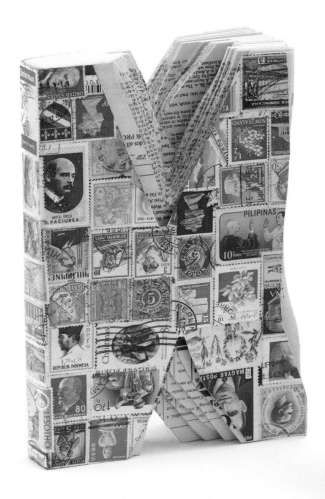

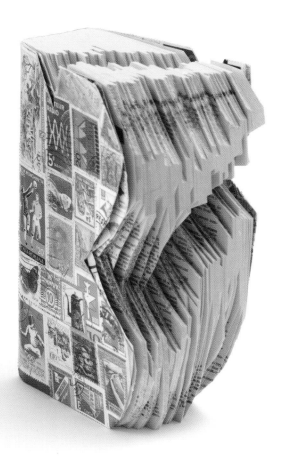

Broken and Mended III, 2017
Salvaged language dictionaries, cancelled stamps
M shaped book: 8 × 6 × 1 inches
B shaped book: 7 × 6 × 1 inches

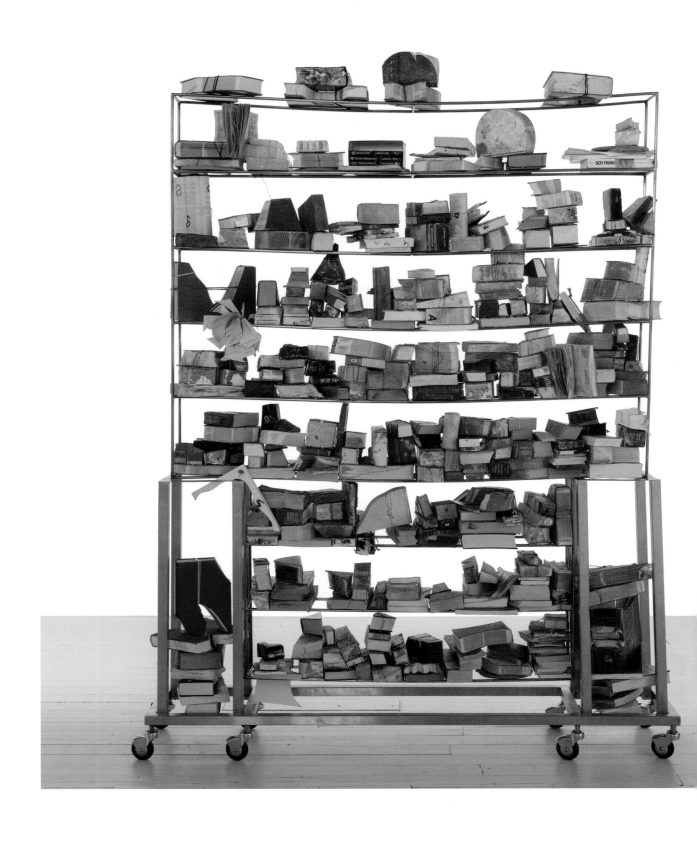

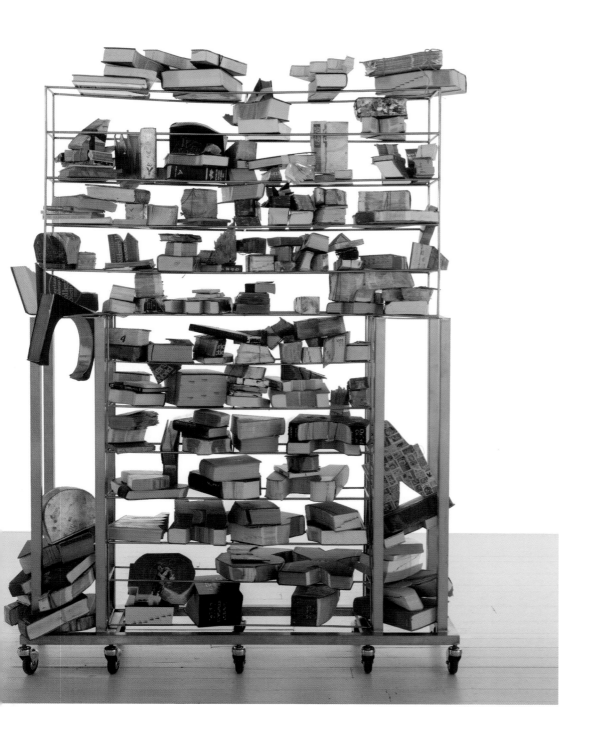

Babel Library – Peace Library, 2019, ongoing
Acrylic paint, gold leaf, rust, tar,
lead, encaustic, stainless steel
83 × 112 × 16 inches

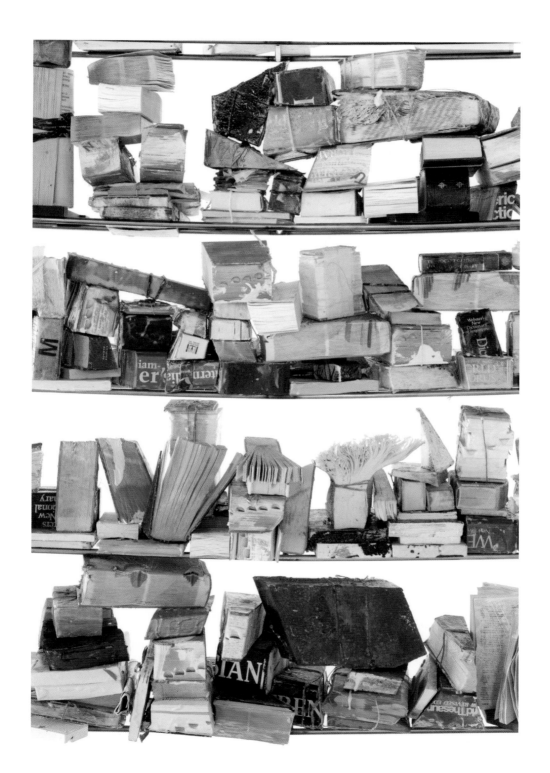

Babel Library – Peace Library, detail

WAM E The Walker Rembrandt,
its languages, DaVinci Augustus Tsearch
Odysseus
Odysseus, Andrea d batty Vandor a Louise
sculpture
exchange, color class,
installation, painting, constellation
ideas, Nico Green
Darwin
experimenting, installation
portraits
Max Beckmann
Dumas
AR, Beauty, Poetry, every
Kandinsky
math, WAM,
ology Greco Roman
guage, Beauty, Cambridge, Fresco

CONTRIBUTORS

Heather Carroll is an archivist, historian, and artist from Minneapolis. Her research focuses on the Women's Art Registry of Minnesota and the feminist art movement in the Twin Cities. She holds a bachelor of fine arts from the Minneapolis College of Art and Design, a master's degree of library and information science from St. Catherine University, and a certificate of museum studies from the University of St. Thomas. She received a Legacy Fellowship from the Minnesota Historical Society to support her research.

Wendy Fernstrum is a writer and visual artist. In 2016 she received the Minnesota Book Artist Award, a category of the Minnesota Book Awards; she has also received a Minnesota State Arts Board Artist Initiative Grant and a Jerome Foundation/Minnesota Center for Book Arts fellowship. Her art is exhibited and collected nationally. She earned a master of fine arts in creative writing from the University of Minnesota and resides in St. Paul.

Joanna Inglot is Edith M. Kelso Associate Professor of Art History at Macalester College. Among her writings on modern and contemporary art are *WARM: A Feminist Art Collective in Minnesota,* which accompanied an exhibition she curated for the Weisman Art Museum at the University of Minnesota, and *The Figurative Sculpture of Magdalena Abakanowicz: Bodies, Environments, and Myths.* She has received a Fulbright Fellowship, an International Exchanges Commission Grant (IREX), and awards from American Council of Learned Societies and the National Endowment of the Humanities.

Lyndel King is director and chief curator of the Weisman Art Museum at the University of Minnesota in Minneapolis. She has been the curator of numerous international exhibitions and is interested in exploring the relationship between art and science. She is a contributor to *The Innovative Museum: It's Up to You…*

Camille LeFevre is an arts journalist, critic, and scholar. She is the author of *Charles R. Stinson Architects: Compositions in Nature* and *The Dance Bible,* a book for high school and college students. She wrote essays for Rebecca Krinke's artist book *Bedtime Stories: Sculptures Reimagined* and has written

for and edited online and print publications throughout the United States and Canada. She has taught arts journalism at the University of Minnesota.

John Lyon is the assistant librarian at the Walker Art Center in Minneapolis, where he curates the Rosemary Furtak Collection of more than two thousand artists' books. He previously worked at the Saint Louis Art Museum, the Andy Warhol Museum, and the Wisconsin Veterans Museum in Madison.

Kerry A. Morgan is director of gallery and exhibition programs at the Minneapolis College of Art and Design (MCAD). She oversees two fellowship programs for Minnesota artists, the MCAD–Jerome Foundation Fellowships for Early Career Artists and the McKnight Fellowships for Visual Artists. She received a BA in art history and history from Smith College and MA and PhD degrees in art history from the University of Kansas.

Marcia Reed, chief curator and associate director for special collections and exhibitions at the Getty Research Institute in Los Angeles, has developed and curated the GRI's collections since its founding in 1983. She is a strong advocate for the significance of artists' books, expressing her belief that these are contemporary versions of artists' centuries-long engagement with books and texts in creative formats. Among the exhibitions she has curated are *The Edible Monument: The Art of Food for Festivals* (2015–16), *Cave Temples of Dunhuang* (2016), and *China on Paper* (2007), all with catalogues. Her award-winning catalogue of the GRI's artists' book collection *Artists and Their Books / Books and Their Artists,* coauthored with Glenn Phillips, accompanied the 2018 exhibition at the GRI.

Susannah Schouweiler is director of communications for the Weisman Art Museum at the University of Minnesota, as well as an arts journalist, critic, and editor. Her writing has been published in local and national publications, including *Hyperallergic, American Craft, Rain Taxi Review of Books, Public Art Review, Ruminator* magazine, MinnPost, *City Pages,* and *The Growler.* She was editor in chief of Mn Artists, an online platform for Minnesota artists at the Walker Art Center, and has also worked at the Minnesota Museum of American Art. She lives in St. Paul with her family.

ACKNOWLEDGMENTS

The creation of this book has been about collaboration and human relationships among all the participants just as much as it reconstructs the inner vision of my art.

Special thanks to the Weisman Art Museum's director, Lyndel King, and senior curator, Diane Mullin, who agreed in 2018 to establish general parameters for the transfer of some of my art to the museum's permanent collection. Without this support, I would not have started this book. I am grateful that the Weisman Art Museum featured the *Young Americans* exhibition in 2020 and offered its premises for a book signing. Further thanks to Lyndel King for assisting with the artwork selection, which required several studio visits and a tenacious recording of the process.

Thanks to the Minnesota State Arts Board for the grant that initiated the creation of *Synthesis—Lost and Found in America: The Art of Vesna Kittelson*. I am thankful that the Minnesota State Arts Board made it possible for an immigrant artist to be considered a member of the Minnesota art community.

Thank you to the great team of essay writers for their creative writing about my life and art: Heather Carroll, Wendy Fernstrum, Joanna Inglot, Camille LeFevre, John Lyon, Kerry Morgan, Marcia Reed, and Susannah Schouweiler. Each was asked to focus on a given category of my oeuvre, and they approached my work with deep understanding of the studio questions and the larger historical context. They could see acutely the connections between the idea behind the art and how it resonated with the world today and the history of art. Each writer is a critical thinker at the forefront of contemporary visual arts.

Special thanks to the publisher of Afton Press, Ian Graham Leask, who approached me with a suggestion of collaboration at the very moment when I needed such an excellent publishing partner. His belief in art is great! In our discussion relating to the content of the book, his attitude was "art first." Thanks to his coworker Beth Williams for being of the same mind and commitment. I am also thankful for Kevin Brown and Molly Ruoho of Smart Set, designers who transform the incomprehensible into the fascinating.

Many thanks to Laura J. Westlund, a very learned editor of art writing, for her helpful comments. I am impressed with her knowledge of art history, and I am grateful for her suggestions of how to make great improvements with small modifications to the text.

Thank you to Rik Sferra, who has been the photographer of my work for several decades. My art would not exist in the public eye without his meticulous photography through all its themes and evolving stages.

Special thanks to my family for enduring my art journey into the unknown. I have been influenced by my husband David's thinking about science and the environment with his gorgeous looking charts and graphs. Thank you to our son, Andrei, and his Brazilian wife, Paula, and their fantastic children, Giovanni and Bella, for their steady support, curiosity about my art, and including my art as part of their living environment.

My final thank you is to all the artists who spend a lot of time in my company talking about ideas, visual images, and the state of art in general.

I am grateful to be able to be visited in my studio, in my imagination, by many historical figures who helped me unlock the grips of uncertainty with their powerful work. There were many knowns and unknowns in the historical periods of ancient marbles, ancient philosophers, Egyptian artists, Greco-Roman artists, thinkers of Enlightenment, Darwin, all mixed with the worlds of Byzantium, Islamic art, African masks, Asian philosophies, totemic art of Native people, Renaissance, and many others. I thank individuals like Francisco Goya, Vincent van Gogh, Rembrandt van Rijn, Elizabeth Murray, Louise Bourgeois, Joan Mitchell, Max Beckmann, Phyllida Barlow, Marlene Dumas, and Pablo Picasso for their profound understanding of humanity's relationships and for guiding me in how to make personal into universal. As an artist, I find myself thinking of Marcel Proust's quotation: "We must never be afraid to go too far, for the truth lies beyond." This is my inspiration to feel free to create strange art and find unexpected connections.

VESNA KITTELSON

MUSEUM COLLECTIONS

Brooklyn Museum Art Library, Brooklyn, New York

Bush Foundation Collection, St. Paul, Minnesota

Cafesjian Center for the Arts, Yerevan, Armenia

Dibner Library of the History of Science and Technology, Smithsonian Libraries, Washington, D.C.

Getty Research Institute, Los Angeles, California

Minnesota Center for Book Arts, Minneapolis, Minnesota

Minnesota History Center, St. Paul, Minnesota

Minnesota Museum of American Art, St. Paul, Minnesota

Tate Library, Tate Britain, London, England

Walker Art Center Library, Minneapolis, Minnesota

Weisman Art Museum, Minneapolis, Minnesota

Yale University Art Library, New Haven, Connecticut

UNIVERSITY OF MINNESOTA
Driven to Discover℠

Special thanks to the Weisman Art Museum, which helped bring this publication to fruition and has supported the artist and her work for years.

CLEAN WATER LAND & LEGACY AMENDMENT

MINNESOTA STATE ARTS BOARD

Vesna K. Kittelson is a fiscal year 2019 recipient of an Artist Initiative grant from the Minnesota State Arts Board. This activity is made possible by the voters of Minnesota through a grant from the Minnesota State Arts Board, thanks to a legislative appropriation from the arts and cultural heritage fund.